MADISON FOOD

MADISON FOOD

A HISTORY OF CAPITAL CUISINE

NICHOLE FROMM & JONMICHAEL RASMUS

FOREWORD BY ERIKA JANIK

AMERICAN PALATE

Published by American Palate
A Division of The History Press
Charleston, SC 29403
www.historypress.net

Front cover, top left: Wisconsin Milk Marketing Board, Inc.; *top center*: Judy Hageman.

All images are provided by the author unless otherwise noted.

First published 2015

Manufactured in the United States

ISBN 978.1.62619.615.5

Library of Congress Control Number: 2015936856

For Love Love Love
Keep circulating the tapes

CONTENTS

FOREWORD

E ben and Rosaline Peck hosted Madison's first Thanksgiving in 1838. The menu was humble: venison, fish, cranberries and native produce. Not a restaurant per se, Peck's Tavern Stand was a boardinghouse the Pecks ran that housed mostly construction workers building the new capitol.

The Pecks had moved to the fledging city from Blue Mounds in 1837 after learning of Madison's selection as the territorial capital. Eben contracted for the construction of two cabins, but neither was done when the family arrived on the isthmus. They served their first meal for guests in May 1837 "under the broad canopy of heaven." The Pecks sold their business after a year of exhausting duties that required, as Rosaline described it, "being a slave to everybody."

Many restaurant owners would likely agree with poor Rosaline. But people would keep coming to Madison, and restaurants would keep opening to serve them.

I moved to Madison in 2002 eager to explore the city that I'd read had more restaurants per capita than any other (an assertion Nichole and JM take to task). Growing up in the suburbs of Seattle, I knew little about my food, nor did I even think to ask. It was, instead, here in Madison at the Dane County Farmers' Market that I tasted the first apple that made me swoon, here that I fell in love with CSA and met real life farmers and here that I discovered the remarkable power of food to make me feel at home.

Falling into a food-loving crowd, I could soon nod along knowingly with longtime residents about legendary restaurants long since gone: the Ovens

FOREWORD

of Brittany, Lysistrata and the Wilson Street Grill. Local tales like the one about the golden statue atop the capitol being not "Wisconsin" but actually Mrs. Rennebohm scouting the next location of the local drugstore chain became a part of my mental folklore of the city. And in my time, restaurants that I loved have come and gone as well: Radical Rye, Café Montmartre, Buraka and Caspian Café.

For years, I've relied on Nichole and JM to point me the way to good food from gas stations and food carts to bars and truck stops (oh, and actual restaurants, too). My dad, despite an abundance of great food in Seattle, used to keep a running list of places he wanted to eat when he visited. Little did he realize the guide I had at my fingertips in "Eating in Madison A to Z."

There's perhaps been no better time than now to eat in Madison. And with articles touting the city's chefs and dining scene across the country, we're certainly not the only people who know it. This book tells us how we got that way.

ERIKA JANIK
Historian and Executive Producer
Wisconsin Life on Wisconsin Public Radio

ACKNOWLEDGEMENTS

We would like to thank the staff at Arcadia/The History Press, especially our editors, Ben Gibson and Julia Turner. The existence of this book is due to their interest, enthusiasm and investment of time in the project. Our sincere appreciation goes to Erika Janik both for her encouragement and her foreword.

This book would have been impossible without libraries and the people who work in them. The following offered valuable resources and research guidance: Ann Waidelich; the staff of the Wisconsin Historical Society Library and Archives; the staff of UW–Memorial Library; Troy Reeves at the UW Archives & Records Management Oral History Program; the staff of Madison Public Library, especially at the reference desk and the copy/ print stations, and all the past clippers, filers and caretakers of the local news folders (because it's not all online—yet); and those folks from all across Wisconsin who work to make online research possible through resources such as BadgerLink.

Gratitude for their time spent talking to us about some unique facets of Madison's food scene is due to Maureen Barry (Grilln4Peace), Michele Besant (Lysistrata), Linda Falkenstein (*Isthmus*), Mitchell George (Redamte), Larry Johnson (Dane County Farmers' Market), Wayne Mosley and Jim Pedersen (Rocky Rococo's), Jeff Steckel (Porchlight) and Mary White (Honey Bee Bakery). Further, we'd like to thank everyone who shared their personal memories of Madison food from years past with us, especially Saverio.

ACKNOWLEDGEMENTS

Many friends shared their reading time and writing talent to help us do our words better, including Connie Deanovich, Ryan Engel, Guy Hankel, Marissa McConnell, Deb Mies, Meghan O'Gieblyn, Amanda Struckmeyer, Janine Veto and Carrie Willard. We'd also like to thank our English teachers, especially Mr. Ceci and Gus.

Without the contributions of the following, this book would not look as good as it does: Kayla Morelli, who provided a drawing of Eddie Ben Elson's Comet Kohoutek ticket; Lisa Marine at the Wisconsin Historical Society, who assisted in procuring historic images; photographers John Benson, Richard Hurd, Joseph Kranak, Kristine M. Stueve and especially Steve Kessenich and Bill Warner and Judy Hageman at Snug Haven Farm, who shared their work; Susan M. Bielstein, who wrote the excellent book *Permissions: A Survival Guide*, and Dorothea Salo, who recommended it.

JM would especially like to thank those who helped him recover from a broken leg, which happened just after we had begun writing this book.

Finally, for their unflagging support and patience, thanks to Lisa, John and Rose and the rest of our families and friends. And for their many years of encouragement, all the readers of "Eating in Madison A to Z."

INTRODUCTION

In 2004, we—food-loving Nichole, who had just finished her graduate degree in library science, and JM, her patient husband, whose idea of fine dining was mixing all of the non-brown fountain soda together—decided (on JM's suggestion) to try eating at every restaurant in Madison in alphabetical order. This we documented on our weblog, www.madisonatoz.com, and despite our lofty goal, we did indeed finish at Zuzu Cafe in February 2012 after visiting 779 restaurants.

Yet we hungered for more, especially more information. We could say we knew of the best spots in town, but we didn't know how they got that way or what they had been before. How did Madison become something of a food mecca in the Midwest? Madison is no Chicago, but it has more and better places to eat than Des Moines or Omaha does. And its dining scene is competitive with the best of Milwaukee, the Twin Cities and St. Louis. What, as they say, gives?

This book is our attempt to answer that question: a brief history of influential Madison restaurants that tells, in its own way, a history of Madison itself. The focus is the twentieth century, with brief spotlights on some nineteenth- and twenty-first-century notables. Most of the places included are located in Madison proper, but some are as far away as Green County.

In researching this book, we looked primarily for stories that demonstrated Madison's character and amused us. Iconic Madison landmarks, along with famous personages like Carson Gulley and Odessa Piper, dot the pages. Additionally, we emphasized places at which one could still eat or, at least,

visit. The grand sweep of Madison history provides the arc, but small stories also reveal surprising connections. We couldn't resist a good anecdote, and we feel the book is richer for it. That said, the stories are mostly dug up from secondary sources (newspapers, magazine articles and the like) with some depth added by interviews, archival resources and our own direct experience.

This leads to our final point: this book is far from definitive. There is so much more to say about the University of Wisconsin's influence, both as a customer base and a source of culinary innovation. There is little proof in these pages of Madison's penchant for beer, wine and spirits. Ethnic cuisines are glanced at but not covered in the depth they deserve—the rise of Southeast Asian, Indian, Mexican and South American restaurants in Madison could fill a whole book this size all by itself.

In broad strokes, then, this is the history of Madison's cuisine. From the humblest burgers to the fanciest greens, Madison finds a way to be in the center of it all. How that happened is an amazing story.

1
THE HISTORY OF MADISON'S FOOD CULTURE

Madison rises from the hills of Dane County in south central Wisconsin as an oasis and a crossroads. Unlike its proximate midwestern brethren like Chicago and Milwaukee, Madison was not a native city that slowly urbanized but rather a panoramic stretch of wilderness where a couple of splendid lakes sat so close together that they almost touched.

James Duane Doty looked at those lakes and saw progress. In 1829, he bought the little strip of land between Lakes Monona and Mendota. Middleton, at the west end of the expansive Lake Mendota, was already there, so the trains already ran past this picturesque plot.

Doty named his town Madison after the recently deceased fourth president of the United States and "Father of the Constitution." As the territorial government of the new state of Wisconsin decided where to place its capital, Doty pitched a capitol building squarely between those two beautiful lakes.

By the time Madison first incorporated in 1846, the legislature had already been meeting there for ten years. It grew tenfold until it incorporated as city a decade later. Madison was always a place where people from out of town (namely, the more than eighty citizen legislators) would need to find a good meal. The early cuisine of Madison primarily catered to them.

1856-1945
THE BEGINNING OF MADISON'S RESTAURANTS

By 1858, Madison boasted six restaurateurs. Most of these early eateries were located on Main, King or Mifflin Streets, all within walking distance of the capitol. William Hopkinson had even opened a restaurant at the train depot that served as Madison's first foray into providing food for travelers.

While the number of restaurants varied little for much of the latter half of the 1800s, it is hard to translate this into a complete picture of Madison's early culinary history. This was partly because of a social taboo against dining outside the home. This may have been the case, in part, because much eating out happened at hotels, saloons or taverns. In pre-Prohibition America, any location serving alcohol was classified as a saloon. Many saloon owners drove up their drink sales by serving reduced price or, in many cases, free food, and most saloon customers were men.

In addition, the number of saloons in early Madison was very high compared to other cities of its size at that time; for example, in 1890, nearly sixty were listed in the city directory. This included places such as the Home Restaurant in the Tenney block on Pinckney Street that most likely served food. By 1895, Madison was also the capital of the home state of Pabst, the largest brewery in the country. At the same time, Madison maintained only two establishments that called themselves simply "restaurants": St. Julien and St. Nicholas, both located near the Capitol Square.

St. Julien opened in 1855 on the upper story of a building on the flatiron corner of Fairchild and Pinckney Streets, the current site of the 1887 Suhr bank building and the Tipsy Cow bar and restaurant. St. Julien shared its name with a patron saint of innkeepers and was open all hours to serve fine liquors and trendy oysters, as reported in the *Wisconsin Patriot*. Its free lunch was offered at a specific hour that varied from 10:30 a.m. to 9:30 p.m. daily and was purely a set-menu affair depending on what foods were available. An announcement in the *Madison Daily Argus and Democrat* from owners Jefferson and Hawkins on February 9, 1857, heralded a real treat for that day's meal: a broiled turkey had just arrived from Cleveland. In 1858, Jacob van Etta took over at the St. Julien, and he and his sometime partner, Jack McGie, ran a billiard hall there. Later owners included Thomas Morgan (who often served lake fish that he caught himself) and his employee Matthew R. Cronin. St. Julien eventually moved into the basement and disappeared shortly before the Suhr building was constructed.

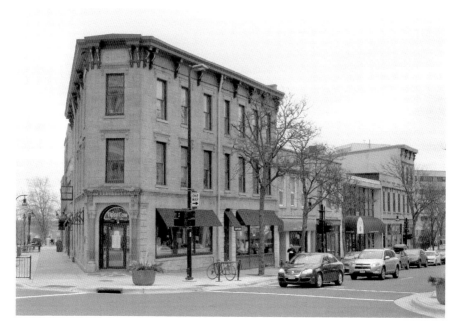

The Suhr building was built in 1887, replacing a structure that had been home to the St. Julien restaurant since 1855. Beginning in 2011, it was home to the Tipsy Cow.

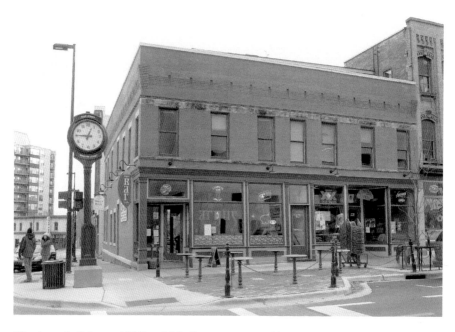

The Argus building at 123 East Main Street was erected in 1847 and housed the *Wisconsin Argus* newspaper. In the late 1990s, it became a bar and grill.

After St. Julien folded, longtime waitress Elizabeth Russ became a cook at its chief competitor, St. Nicholas, and worked there for about twenty years. Originally, St. Nicholas was in the basement of the Young block building at Main and Carroll Streets, which brothers Peter and Michael erected in the 1860s. The business model was similar to St. Julien's, with its free lunch and long hours, but St. Nicholas evolved with the times into what today would be seen as a regular restaurant. Albert Cheney assumed the business and moved it to 120 West Main Street. In 1910, employee Ben Stitgen bought it. Soon ads for the "New St. Nicholas" appeared. Stitgen sold to Walter Hicks in 1925, and Hicks's son Fred took over during the Depression. When the building was razed in 1946, Krug was the owner; St. Nicholas's end was mourned by fans of its famous "steaks, fowl and fish."

The geography of this youthful Madison was quite small. Many university students in modern Madison have to travel farther for classes in a day than someone walking the perimeter of the city would have traveled in 1880. By 1910, the city had only expanded about three miles in any direction from the capitol. The enclave of Maple Bluff already abutted the city, but Shorewood Hills was a separate village. Another neighborhood was just being established at the south end of what is currently Monroe Street. At the time, it was home to a tavern called the Plow Inn ("and Stagger Out," today the Arbor House Bed and Breakfast), an edge-of-town kind of dive.

Between 1890 and 1900, the number of restaurants quadrupled, and it had quadrupled again by 1909. A few of these early century eateries are very beloved in Madison history, among them Cleveland's, which operated from 1909 to 2008 under the same name, and E.W. Eddy's One Minute Lunch, pioneer of dining trends from 1899 until 1928.

E.W. Eddy learned short-order cookery at the 1893 Chicago World's Fair. He came to Madison to study journalism at the University of Wisconsin (UW) and worked as a newspaperman until, in 1898, he pedaled his bicycle to Omaha for the Pan-American Exposition. There, he spent a few months learning the ropes at a One Minute and, in 1899, brought the idea back to Madison. He set up shop at 7 West Main Street in a small space designed to look like a railroad dining car, and it became a favorite lunch spot of Robert LaFollette, the famously Progressive politician, and other busy folks looking for a quick bite. In 1916, Eddy's One Minute moved to the turreted building at 119 King Street and was the first in Madison to take up the cafeteria-style service trend that had become popular across the country about five years prior. The King Street location had its own café on the first floor; the bakery, laundry and business office on the second; and the kitchen on the third. It

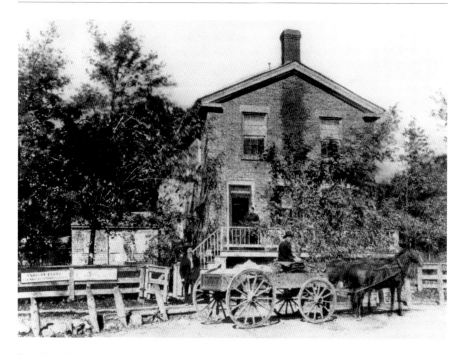

The Plow (Plough) Inn, 3402 Monroe Street, was established as a tavern around 1858 by John and Isabella Whare. *Wisconsin Historical Society, WHS-50970.*

became the hub of a mini-chain with outposts at 903 University Avenue and 213 State Street. In February 1928, it was also the last to close. After a brief effort to resurrect it by Martha Woerpel, a manager at rival cafeteria Piper Brothers, the restaurant at 119 King Street was replaced in 1931 by the first of many furniture stores at that address. At the dawn of the twenty-first century, Madison's Dining and Diversions opened as a restaurant and club in the historic building.

While the end of the Great War was a significant milestone in much of the West, it was the coming of Prohibition that really shaped Madison's scene. The pattern of fourfold growth was not sustainable, but Madison was up to more than forty places to get a bite to eat by 1919.

In the 1920s, Madison kept expanding its borders by both creeps and bounds. During this booming period, Madison gained a municipal airport just beyond the north end of town. The university started growing westward between University Avenue and Lake Mendota, eventually annexing Picnic Point, which was already known by that name. The Plow Inn was now certainly within Madison's borders, and houses started to ring a pair of golf courses situated in the Nakoma and Westmorland neighborhoods. By

decade's end, Shorewood Hills would be across the street from Madison, and while the north side of Lake Monona was parkland, houses farther east of it were already within the city.

Of course, the number of restaurants also boomed during this period. What had been fewer than fifty dining halls grew to over one hundred. Several of the new "restaurants," though, were bars and taverns that had started serving food and stopped serving alcohol during Prohibition. Instead, they provided tumblers, ginger ale and ice with a wink and a nod.

The crash of 1929 had far-reaching effects, even in Madison. During the 1930s, the number of restaurants remained stagnant, though the city grew in both size and stature. By 1939, Madison had its first "chains" serving students: Weber's had two locations, one on State Street and another on Johnson, and Lawrence Lunch had spots on University and State Streets.

The '30s also saw a rise in teashops. Green Lantern Tea Room, Wooden Bowl Tea Room and Ye Olde Fashioned Tea Shoppe all offered a counterpoint to the coffee shops that were prevalent downtown even then. Progressive Madison even had a "New Deal Restaurant," though one wonders if a Social Security Skillet or a BLTVA would have been on the menu.

ONE RESTAURANT FOR EVERY 202 PEOPLE

They say that Madison has the most restaurants per capita.

Wait a minute.

Who says that? Do they cite any hard facts? How is the number calculated?

Sadly, Madison does not appear to be the winner of the category most restaurants per capita ("RpC" for short) despite having a lot of places to eat and relatively small size. Looking at a county-by-county breakdown, Dane County, Wisconsin, is nowhere near as overpopulated with eateries as New York County, New York. Indeed, many touristy northern Wisconsin counties have better ratios than Dane because it doesn't take that many eateries to swing the pendulum.

Furthermore, authoritative sources that have scrutinized the metropolitan areas that lay claim to the RpC have tended not to go as far down the list as the modestly populated Madison area. (These usually find San Francisco toward the top of their lists). Restaurant

information by city is hard to gather, as "cities" are not blocks used by the economic census.

At its earliest, the spark of the idea goes back to the early 1970s. Lyle Poole, president of the Wisconsin Restaurant Association, was reported in the *Capital Times* of July 16, 1970, as saying that Madison has "far more per capita good eating spots than Milwaukee." On January 29, 1971, the *Wisconsin State Journal* reported, "Madison is blessed with an abundance of restaurants of quality and variety of style and cuisine. The city draws more visitors in relation to its size than any other community of Wisconsin." Almost three decades later, Ovens of Brittany CEO Mark McKean told the trade journal *Restaurants and Institutions* that Madison "boasts five times the national average" of RpC.

These uses of restaurant density point toward the culprit, but they are far from conclusive. Typing "most restaurants per capita" into a search engine reveals some studies for which Madison is too small to even appear. Further, Texas metros like Houston, Dallas and Addison show up as often as Madison does in the self-promotion of the per capita title. But there is one Madison result that comes up quite near the top when searching for this RpC claim, and it is from the Greater Madison Convention & Visitors Bureau.

The bureau has been touting this factoid as truth for over three decades and, for several years, made it part of the boilerplate text that introduced the dining section of its annual visitor's guide. Never once has it cited a published statistic or report that indicates whence this data comes. From their repeated insistence, it has entered the Madison community wisdom as a "fact" regardless of its nebulous provenance.

There was a report published in 2009 by the now defunct bundle.com that showed spending on restaurants versus groceries among major U.S. cities. Madison placed second on this chart behind Atlanta in restaurant spending as a percentage of total food spending. Furthermore, Madison was twelfth on total restaurant dollars spent per capita behind such heavy hitters as Austin; Arlington (Virginia); Washington, D.C.; Raleigh; Nashville; San Jose; San Francisco; Durham; Scottsdale; Irvine; and Honolulu.

That said, for a city of Madison's size, there are a lot of nice places to eat.

1945-1972
Steak Houses, Pizza Parlors and Chinese

In the postwar period, Madison began to develop a more clearly defined east-west divide. Since the isthmus is quite narrow and the downtown area runs from Lake Monona to Lake Mendota, it stands to reason that an "east side" and "west side" would develop. Additionally, since the university was nearly entirely on the west side, it was natural that university faculty would be drawn to west side neighborhoods more than east side ones. Residential areas of the east side clustered around the burgeoning Oscar Meyer factory and other blue-collar employers. In short, Madison's east-west divide was becoming socioeconomic as well as geographical.

Those who grew up in Madison of the late 1940s through the '60s report that the "sidedness" of the town was real. Madison East and Madison West High Schools were bitter rivals whose acrimony only increased once Central High closed in 1969. Some hints of the east-west divide show up in restaurant listings, too. In 1950, the East Side Cafe, found at 1937 Winnebago, would have been toward the edge of town.

There were, of course, exceptions to the divide. The Greenbush neighborhood (literally across the tracks from the central city, in the triangle between West Washington Avenue and Park and Regent Streets) was its own thing—mostly working-class families of Italian heritage. There, you could find classic Madison eateries and taverns with names like Amato's, Schiro's, Schiavo's and Di Salvo's. These are places that inspire nostalgia in many Madisonians to this day. In particular, Catherine Tripalin Murray has been the faithful chronicler of the Italian heritage of the Greenbush. In *Spaghetti Corners and All That...Sauce*, she writes the oral history of the patriarchs of the neighborhood. The title is a reference to the intersection of Regent and Park Streets, where several Italian restaurants operated by the 1940s. The neighborhood drew in the military flyboys arriving at Truax Field, who visited there looking for a good time and usually found it.

One favorite spot was Bunky's, operated by Vito and Ninfa Capadona at 3 North Park Street from the 1930s to the late 1960s. In the 1950s and 1960s, across town at 2009 Atwood Avenue (the future home of Pasta Per Tutti, Luna Cafe and Tex Tubb's), John Capadona ran Bunky's Grande Bar. In 2004, his niece (and Ninfa's great-granddaughter) Teresa Pullara-Ouabel and her husband, Rachid, opened their own Mediterranean-influenced version of Bunky's at 2827 Atwood, the space that had previously been Sole

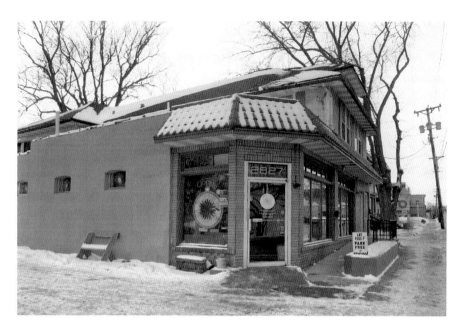

Daisy Cafe & Cupcakery opened at 2827 Atwood Avenue on May 18, 2009, replacing Bunky's.

e Sapori, ArtHouse Cafe and Leske's Supper Club. In 2009, Bunky's moved again, landing at 2425 Atwood in a former community center.

Another Greenbush dynasty was the Schiavo family. Jimmy Schiavo's Stone Front Tavern at 531 Regent Street was the first of the family's many successful Madison restaurants, followed by the Continental at 4212 East Washington. His son, Tony, got started as a dishwasher at Amato's Holiday House and then went on to run his own place, Antonio's, at 1109 South Park Street with his wife, Rose Marie. In 1998, they opened Cafe Continental at 108 King Street. Cafe Continental closed in 2011 but not before Tony's son, Jim, bought the La Paella building at 2784 South Fish Hatchery Road from Tomas Ballesta and turned it into another Continental. The Fitchburg Continental closed abruptly in 2012. It reopened as Veranda under Nick Schiavo, Rose Marie and Nick's wife, Stephanie, but by 2014, Veranda was shuttered and the Schiavo family was, for the first time in many decades, no longer an active part of the Madison restaurant scene. Indirectly, their influence continues through notable modern-day Madison restaurateur Shinji Muramoto, who got his start at the King Street Continental.

The Greenbush fell to urban renewal in the early 1960s. Today, Fraboni's still serves its Italian specialties at 822 Regent Street. The Italian Workmen's

The Greenbush Bar opened in 1993 in the basement of the historic Italian Workmen's Club building.

Club at 914 Regent Street houses the Greenbush Bar, a kitchen helmed by Anna Alberici. But other than that, Greenbush is a memory; Greenbush Bakery, with its delicious kosher donuts, opened decades after the bulldozers rolled through.

The plight of the Greenbush neighborhood underscored many of Madison's socioeconomic divides, but in terms of unity, one chain by the 1960s had become the very definition of ubiquity: Rennebohm's. "Rennie's" were drugstores in the classic tradition, complete with soda fountains. Some folks even claimed that Daniel Chester French's golden statue atop the state capitol building was not actually "Wisconsin" but Mrs. Rennebohm scouting her next location. Also sprouting up was the chain of Hoffman House eateries, a bunch of dark-paneled, white tablecloth affairs that were perfect for special occasions.

The supper clubs of the '60s read like a veritable who's who, including Leske's on the southern end of Monona Drive, Crandall's downtown (where the Tornado Steakhouse now stands), Cuba Club near Shorewood Hills and Nob Hill overlooking the southern end of Lake Monona. These places are, to a one, gone today. Their spirit lives on in Smoky's on University Avenue

(in the spot formerly occupied by bootlegger queen Jennie Justo's place), Wonder Bar (another spot with romanticized crime ties) and Kavanaugh's Esquire Club on the north side. The Wisconsin supper club tradition has further been reinvented in places like Old Fashioned on the Capitol Square, which combines traditional menu choices with a twenty-first-century attitude and supply chain.

Nom Yee's Chinese and American Restaurant, Madison's first Chinese eatery, opened in 1945. Nom Yee came from Canton Province to Madison via Cleveland; he ran his restaurant at 119 Webster until the state bought the building in 1970. He moved to 208 King Street in the Capitol Hotel, but the state bought that building in 1973. He moved to 678 South Whitney Way, where he stayed in business until his retirement in 1978. Yew K. Low's Cathay House at 2524 East Washington Avenue opened in 1955 and, in subsequent decades, attained almost mythical status among baby-boomer Madisonians who pined for the place where they had first had a taste of egg fu young.

On the chain front, Kentucky Fried Chicken opened locations on Park and Main Streets, and an A&W Root Beer stand also arrived on Park Street in the '60s. Even Milwaukee's finest chain of diners, George Webb, had a Madison outpost on Mifflin Street. Animatronic trolls festooned the smorgasbord at the Jolly Troll in Hilldale Mall, and both Mr. Steak and Nino's Steak Roundup offered a lower-cost high-end dining experience.

Madison's restaurant choices at the end of the tumultuous '60s were mostly staid and solid, watered-down "ethnic" eats or just plain goofy. In her 1974 guidebook, *Getting the Most Out of Madison*, Janice Durand summed it up thus: "Five years ago, if you wanted to go out to dinner, you could take your pick of a steak house, a fancy steak house, a pizza parlor, or a Chinese-American eatery." Ham-fisted urban renewal and the unstoppable glacial expansion of public buildings had crushed some genuine communities. But a huge change was soon to come.

INFAMOUS FIRES

Fire is a natural hazard for restaurants. Cooking, smoking and drinking combine with carelessness aggravated by fatigue and long hours—or, in some cases, malicious intent—to result in more conflagrations than average. Madison restaurants have had their fair share of fire stories.

Early Twentieth-Century Fires

Organized firefighting in Madison dates back to 1856, and the professional Madison Fire Department was established in 1908. Its first decades were marked by relatively safe operations. On June 10, 1939, Madison lost its first firefighters in the line of duty while they were attempting to extinguish an early morning blaze at the Mary Ann Bake Shop at 602 Park Street. Adolph N. Habich and Judson H. Holcomb were in the basement when the bakery's heavy oven collapsed through the fire-weakened floorboards.

Food was a key ingredient in the largest fire in Madison's history, the Central Warehouse & Storage blaze that challenged firefighters for eight days in May 1991. Fifty million pounds of stored butter, lard, cheese and other foodstuffs melted, mixed with water and debris and flowed toward nearby Starkweather Creek.

The largest Madison restaurant fire—and possibly the second largest ever after the Central Storage "butter fire"—ignited sometime around 2:00 a.m. on December 6, 1946. A four-alarm fire at the Heidelberg Hofbrau at 20 West Mifflin Street caused a half million dollars in damages and hospitalized three firefighters. Discarded smoking materials were blamed for the fire. Hampered by wooden partitions and piles of "rubbish," firefighters extinguished the flames at least six separate times, but the fire reignited each time heat reached any of the restaurant's large stores of liquor.

Cuccia Arson Case

The loss of Josie's Spaghetti House to an accidental fire on July 17, 2004, destroyed one of Madison's strongest links to the old Greenbush. Almost exactly seventy-three years earlier, and just across the road at 903 Regent Street, a fire had also claimed the Nicholas Cuccia restaurant under more sinister circumstances.

Around 2:00 a.m. on July 21, 1931, young Charles Cuccia ran into Madison General Hospital engulfed in flames. Near death from his burn injuries, he confessed to having committed arson. The gasoline he'd used had splashed onto his clothes and ignited, sending him

running for help; the fire destroyed the inside of the Nicholas Cuccia restaurant, as well as the Francis Pharmacy and a doctor's office in adjoining buildings, but no one else was injured. Charles also told police that the restaurant's owner, Nicholas Cuccia (no relation), had offered him fifty dollars to set the fire. Nicholas was arrested on July 22, and Charles spent several weeks in critical condition.

The case went before Judge A.C. Hoppmann in October. District attorney Fred Risser defended Charles. Initially, their case was strong, as another young man had approached Risser willing to testify that Nicholas had offered him money to set the fire. But when the second witness backed out, Risser amended the case. Nicholas pleaded nolo contendere to the charges in order to avoid a trial. Ultimately, Judge Hoppmann sentenced Charles to one to five years in a youth reformatory and fined Nicholas $750 plus court costs.

Arson in the 1970s and 1980s

The late 1970s saw quite a few dramatic instances of arson, and intentional fires became so common that by the early 1980s, the fire department instituted an arson task force. On February 19, 1976, arsonists struck four downtown Madison buildings, causing over $21,500 in damages to apartments and the Park Motor Inn. The Library Lounge at 131 West Wilson also suffered from a basement fire that started with a pile of books. Three years later, arsonists also hit the West Side Businessmen's Club and the Parthenon Restaurant at 6824 Odana.

Another casualty of arson was Lysistrata. Opened on December 31, 1977, Lysistrata was a groundbreaking cooperative-run feminist gathering space and restaurant. The building at 325 West Gorham included a bar, dance floor and meeting rooms and, for the next three years, offered a hospitable place for community groups and events of all kinds. It quickly became a hub of feminist and LGBT social life in Madison where anyone, from new students to the city's most prominent activists, could feel welcome. At that time, the Madison Police and Fire Departments were actively recruiting women and often found new hires at Lysistrata. Restaurant reviewers praised Lysistrata's delicious food, good prices and nice atmosphere (but warned diners of the slow service).

In late 1981, Lysistrata ran into financial trouble and closed temporarily, reopening with reduced hours. A staff unionization effort and changes in leadership and management also added to the unrest. Tragically, history will never know how Lysistrata would have handled these difficulties because on the early morning of January 8, 1982, a three-alarm fire utterly destroyed Lysistrata, the Living Room teen lounge next door and three other businesses: Jewels, the Flour Box Bakery and a sign painter. The fire was huge by Madison standards, resulting in over a half million dollars in damages. Within a month, the fire department had determined that the cause was arson. No suspect was ever arrested, though evidence suggested that Lysistrata was not the target. The site's owner unsuccessfully petitioned the city to create a rental parking lot, and today, the corner is home to Chaser's Bar and its patio.

Hotel Washington

Madison's LGBT community suffered another loss on February 18, 1996, when the historic Hotel Washington at 636 West Washington Avenue went up in flames. The hotel was built as the Hotel Trumpf between 1904 and 1906, and in 1916, August Horbort renamed it the Hotel Washington. Its proximity to the train station at West Washington Avenue made it a desirable property, though it fell into near flophouse status by its later years. In 1961, Louis and Herman Wagner, who also ran the popular student hangouts the Flame and Campus Soda Grill, bought the hotel. They sold it in 1975 to Rodney Scheel, later bringing three separate lawsuits against Scheel and the realtors for "falsely inducing the sale to a known homosexual," for Scheel's alleged lack of proper care of the hotel and for the Wagners' inability to collect unemployment (they had been offered jobs but didn't accept).

All three cases were dismissed, and Rodney and his brother, Greg, devoted the next two decades to creating a number of successful and beloved businesses in the historic setting. They created the New Bar, a dance and video nightspot that kept the "New" moniker for many years, and renovated the Original Speakeasy, which became the intimate Barber's Closet. The original Hotel Washington Bar became Club de Wash, a legendary concert venue. Wanda's Cafe became the HOT L

Cafe and then Cafe Palms, which had a menu that made many end-of-year favorites lists, especially for late-night eaters.

The fire that destroyed the entire complex began in the early hours of February 18, 1996, in a wastebasket of the Cafe Palms office. After the blaze was extinguished, there was some speculation of arson, specifically with the LGBT community as a target. The fire was ruled accidental—a too-hot ashtray was to blame—and the Scheels attempted to raise funds to rebuild. Ultimately, their plans fell through, and the spot near the train tracks became a gas station.

Underground Food Collective

Since about the turn of this century, a loosely affiliated group of young food advocates (for want of a better term) called Underground Food Collective (UFC) has been a presence on the Madison food plate. UFC's endeavors have included partnerships with heritage pork farmers, the establishment of Bike the Barns fundraising rides to benefit community-supported agriculture, vocational training for at-risk youth at Ironworks Cafe and using both a grant from the Wisconsin Department of Agriculture's Specialty Meat Development Center and a grass-roots Kickstarter campaign to crack open the complex laws and regulations of commercial sausage making. And that's just behind the scenes; UFC fans have been able to sample plates at Catacombs Coffeehouse in the Presbyterian Student Center from about 2002 to 2004, Dane County Farmers' Market breakfasts since 2004, Madison Public Library functions since 2013 and at pop-up dinners from Madison to Brooklyn, New York.

In October 2010, Underground Kitchen, the long-anticipated Underground Food Collective restaurant, opened in the former Café Montmartre space at 131 East Mifflin Street. Underground Kitchen was feted by the food fans of Madison but remained open for less than a year. Early in the morning of June 30, 2011, an accidental fire that started in Underground Kitchen engulfed the entire building, destroying the apartments above the restaurant as well as a hair salon and Mercury Restaurant next door. Very little could be salvaged from either the businesses or the apartments, but no one was injured.

Heritage Tavern replaced Underground Kitchen at 131 East Mifflin Street after a devastating fire.

Undaunted, Underground continued. It opened its second restaurant, Forequarter, at 708¼ East Johnson Street on February 23, 2012. The same year, plans for another restaurant named Middlewest on Williamson Street were announced, and Underground Butcher opened as a storefront and sandwich spot for the charcuterie branch of the collective. With a 2013 nod from the James Beard Foundation to Forequarter as Best New Restaurant, UFC shows no signs of stopping. Likewise, the site of the devastating 2011 fire became the home of Heritage Tavern, and in 2015, Jonny Hunter of Forequarter and Dan Fox of Heritage Tavern were both James Beard Foundation award semifinalists for Best Chef: Midwest.

1972–PRESENT
Something Bigger Than All of Us

The Vietnam War galvanized UW–Madison students and drew the city into a decidedly liberal frame of mind while attracting many like-minded newcomers. Furthermore, many of those hippies and ex-hippies started settling down to open food businesses that reflected their progressive values while still providing delicious repasts. The biggest stories of this era were

A HISTORY OF CAPITAL CUISINE

Ovens of Brittany and the Dane County Farmers' Market, which both came on the scene in the early 1970s.

Record high employment rates, especially for women, made going out to eat a more frequent and attractive option than cooking. The finalization of Madison's Beltline highway gave the city a wider and broader reach both for commuters coming in and diners going out. Legislators continued to wine and dine in ever better venues. As such, the Madison restaurant scene moved from typical midwestern to unique and cosmopolitan in a span of twenty-five years.

In 1974, State Street became a pedestrian mall. This single piece of municipal legislation centralized the city's core retail and entertainment district. Restaurants for students, government employees and business folks developed along its edges, eventually edging out the diverse retail options of yesteryear. Even today, the city is attempting to control the number of eateries along State Street in an effort to ensure that local retail can find purchase against the avalanche of food options.

The UW–Extension Recreation Resources Center reported rapid growth in the number of Wisconsin restaurants, particularly in the Madison area, every year from 1974 to 1979. During this period, Madison boasted two flourishing pizza chains that expanded during the '80s: Pizza Pit (which encouraged delivery order with cute wintertime commercials) and Rocky Rococo's (named after a character in a Firesign Theater sketch).

While Rocky's is still a significant player in the Wisconsin food scene, its size has diminished since its high-water mark of the late '80s. Currently, there are still about forty Rococo pizza places in Wisconsin, plus one each in Minnesota and Washington, which serve as reminders of when the chain extended beyond the Midwest and as far away as Florida. There are still two party pizzerias in Madison, where Rocky himself, Jim Pedersen, often welcomes pizza partiers with a joke and a song. Rocky's 1993 EP, *Kitchen Licks*, is a sought-after collector's item.

Speaking of Italian, the '70s saw the rise of several noteworthy Italian places outside the Greenbush neighborhood. Paisan's, Porta Bella and Lombardino's all arrived in the decade and a half leading up to 1980. Madison's Chinese market opened up significantly at this time, as well. In 1977, Madison still managed to host only five places for Asian cuisine. Within seven years, the number of Chinese eateries ballooned to twenty-three.

Also new in the '70s was L'Etoile, which was to become Madison's first ever true fine-dining restaurant. L'Etoile was founded by Odessa Piper in 1976 and has been serving some of the best meals in Madison since.

Rocky Rococo's introduced pizza by the slice to Madison diners in 1974.

In the 1980s, L'Etoile was a dueling partner with L'Escargot in Fitchburg for Madison's best upscale restaurant.

Along with the rise in fine dining came the rise of casually upscale seafood. Examples of this include the Mariner's Inn and its sibling Nau-Ti-Gal, both located on the northern shore of Lake Mendota. Captain Bill's joined these Von Rutenberg enterprises in the late '80s as seafood options became more than just Red Lobster.

The rapid growth of the Wisconsin restaurant industry came to an abrupt halt in the early '80s, coinciding with the arrival of many popular chain restaurants. These included Chi-Chi's, Chili's, Applebee's and later Olive Garden. Despite the squeeze this placed on hometown favorites, some new enterprises appeared, including Michael's Frozen Custard, where Michael Dix served his grandmother's recipe for the frosty treat in a former Mobil service station, originally built in 1935. Monroe Street once boasted twelve gas stations, though today, there are none; federal environmental protection measures introduced in the early 1980s required facility upgrades that priced many small stations out of business. Michael's went on to become a local chain with several locations.

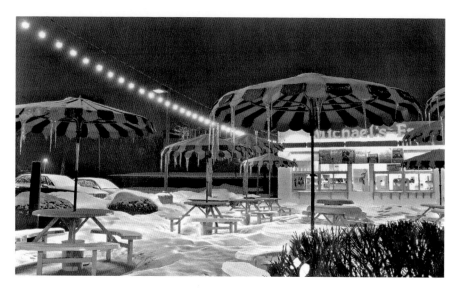

Michael Dix opened the first Michael's Frozen Custard at 2531 Monroe Street on August 22, 1986. *Richard Hurd CC BY 2.0.*

The '90s was a time of consolidation of the gains of the previous decades. Madison also began to incorporate international cuisine. Imperial Garden dominated the conventional Asian market but not so much that Bahn Thai (an '80s newbie), Lao Laan-Xang and Sa-Bai Thong couldn't compete. Madison began to see Indian restaurants open with Maharaja and Taj Indian, as well.

While downtown continued to be the most coveted place for bistros to open, many found success at other locations. Williamson Street and the Schenk-Atwood neighborhood began supporting more and more places, including the first restaurant by restaurant group Food Fight, Monty's Blue Plate Diner, in 1990. The influential restaurant group's second location, Bluephies, appeared on Monroe Street in 1994 and its Hubbard Avenue Diner opened in Middleton in 1998. It was not until the early 2000s that the Food Fight model for shared business operations and independent management opened a couple of places downtown (Johnny Delmonico's for steak and Ocean Grill for seafood).

West Towne Mall, once pocked with chains such as TGI Friday's, began to draw smaller players into its satellite spaces. Madison's love of Chi-Chi's gave way to a preference for Laredo's, a local chain of Mexican restaurants known for their low-cost/fast-service lunches and ubiquitous red gravy.

By the turn of the century, Madison looked much as it does today. Renovation and increased density plans for downtown continued apace.

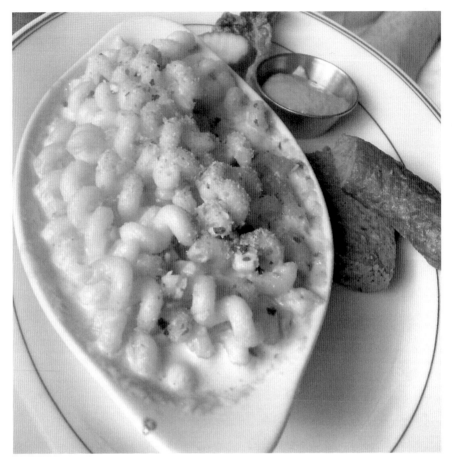

Old Fashioned's classic mac and cheese with Wisconsin sharp cheddar and SarVecchio, with Fendt's ring bologna on the side.

For every venture that closes after a few months, two more seem to take its place. The diversity of offerings continues to expand such that Madison now boasts an Indonesian restaurant, a couple of Peruvian places, a specifically Nepalese eatery and a handful of Korean joints.

Furthermore, in keeping with Madison's progressive ideals, places that list where their ingredients come from do not start and end with L'Etoile. The most significant restaurant in this matter is Old Fashioned, which promises Sconnie cuisine (indicating Wisconsin pride) done well. Its menu of favorites like brats and mac and cheese indicate the Wisconsin source of the items. Several similar places have opened to catch their overflow, such as the Fountain and Tipsy Cow.

A HISTORY OF CAPITAL CUISINE

Madison has also grown out to meet its neighbors. Whereas reaching Middleton used to entail a bit of a country drive, it is now impossible to see the line between it and Madison. The eastern suburbs of Sun Prairie and Cottage Grove are growing along Madison's eastern border and beginning to offer their own fine-dining establishments. As the growth of Epic Systems, a large healthcare software company in Verona, increases, the southwest side has much more to offer than only the superb Quivey's Grove, with Jordandal Cookhouse, Tuvalu and Sow's Ear as examples.

The rise of Marigold Kitchen as a downtown breakfast/lunch place led to Sardine, home to one of Madison's favorite brunches in a beautiful spot with a Lake Monona view in the crook of the Willy Street neighborhood. Food Fight restaurants continue to expand. The group now has interests in no fewer than seventeen major eateries in the Madison area, ranging from upscale burger bar DLUX to Tex Tubb's Taco Palace, a taco joint with its approach straight from the heart of Austin, and Sun Prairie's Market Street Diner.

Additionally, whereas twenty years ago, Pedro's, a relatively staid Mexican and drinks spot, might have been considered the best happy hour in town, Madison now has some bars serving ritzy nibbles to go with their ritzy cocktails. For instance, Merchant and Nostrano focus on great food as well as great drinks.

Even this cursory survey of the modern landscape misses much. Recent years have seen the rise of Glass Nickel Pizza to supplant Pizza Hut; Wasabi, Ginza and Edo and what they know about midwestern sushi; the growth of the Park Street corridor, which features Peruvian, Pan-Asian and Mexican gems all walking distance from one another; the later proliferation of solid Indian places, including Dhaba, Maharani and Swagat; the rise in the number of beer bars and brewpubs, such as Ale Asylum and Dexter's, serving awesome eats; and so much more.

The rest of this book will focus on unpacking many of these stories in more detail and further fleshing out the history of why Madison has so much good food today. Still, the best way to find out about it is to come and eat. Whether you are moving to Mad City, visiting briefly or have lived here since Nibble Nooks and Rennebohm's outnumbered the places where food from the eastern hemisphere could be found, you will find some new stories and an affectionate documentation of Madison's quirks and calories.

2
LAND, LABOR, CAPITOL

M adison's farms, workers and capitol building have unique relationships
with the city.

LAND
DANE COUNTY FARMERS' MARKET AND RESTAURANTS

Most Saturday mornings on the Capitol Square, the Dane County Farmers'
Market (DCFM) is such a counterclockwise force that it's hard to imagine a
time when it wasn't there. DCFM is the largest producer-only market in the
country and attracts 200,000 shoppers over the course of a year. The market
has run year-round (moving inside to Monona Terrace and Madison Senior
Center) since the 2002 season began, offering local foods even in the depth
of the Wisconsin winter. But it was not always so.

From the mid-nineteenth century on, East Washington Avenue between
Pinckney and Webster Streets was a gathering place for marketers from the
countryside. In 1910, the official City Market was built, but after World War
I, it lost steam. Vendors might come to a Madison street corner or parking
lot to try to sell a bumper crop, but nothing was official or sanctioned.

Jonathan Barry became one of those vendors. Originally from Shorewood
near Milwaukee, Barry ran a downtown Madison gift shop in the late 1960s
and eventually was elected Dane County executive. In the summer of 1972,

though, he was mostly growing produce in Mount Horeb and trying to sell it on State Street in front of Ella's Deli. Once too often, he ran afoul of the city parking attendants and finally asked Ron Jensen of the UW County Extension office for help in finding a place to vend vegetables.

Jensen and his colleague James Schroeder had limited success setting up a farmers' market at malls like West Towne and Hilldale. With Barry in the mix, and a great deal of support from Madison mayor Bill Dyke and the Central Madison Committee (later Downtown Madison, Inc.), they came up with a pilot project.

On September 30, 1972, Barry checked in a grand total of no more than eleven vendors to the very first Dane County Farmers' Market at the corner of Main Street and Monona Avenue (later Martin Luther King Jr. Boulevard). There were no fees or rules for vendors. Several hundred shoppers showed up and the farmers sold out quickly. The market ran again the following Saturday, and the vendor count was up to eighty-five, spilling all the way onto the square. A few thousand customers came and also packed nearby Penney's and Kresge's, to the department stores' delight.

The following season welcomed a couple hundred vendors, who paid seventy-five cents per day or ten dollars for a season pass to set up around the Capitol Square. Steady growth led to the opening of a smaller midweek market in 1975. Barry departed to pursue politics, and the market sponsors hired farmers—first Dan and Judy Peterson, later Paul and Jo Ann Prust—to manage the market. A "Growers' Council" was formed to handle the issues of a rapidly growing organization.

The market incorporated in 1983 as Dane County Farmers' Market on the Square, Inc., with a board of directors and an elected Growers' Council. First-time vendors without season passes could still just show up on a Saturday and sell a couple bushels of their bumper crop, but rules were forming to preserve the market's integrity as a Wisconsin producer–only market.

In 1984, the corporation brought on its first manager who was not a farmer. Mary M. Walters, a former Peace Corps volunteer with a background in meat science, served DCFM for five years, during which farmers' connections to local restaurants truly began to take root.

It's hard to overstate the importance of the symbiotic relationship between the restaurant L'Etoile and the market. Since the early 1970s, dozens of restaurants and farms have struck up working relationships, and luckily for all, Madison's appetite for farm-based dining is seemingly insatiable.

Odessa Piper's influence on area chefs was a driving force behind their adoption of the locavore ethic (i.e., that food grown locally should be

significantly incorporated into local cuisine). She also encouraged farmers to coordinate with one another and create demand for their high-quality products beyond Madison. In a related move, in 1996, the Home Grown Wisconsin vendor co-op was established to market to restaurant buyers in Milwaukee and Illinois. This trend was not limited to high-dollar restaurants, however; years later, when Ian's Pizza opened in Chicago, it tried to keep locally sourcing their ingredients. It found the goods available in northern Illinois to be very limited compared to the bounty of southern Wisconsin, so the restaurant decided to bring in produce from Keewaydin and other familiar DCFM names. Meanwhile, sweet hoop-house spinach from Bill Warner and Judy Hageman's Snug Haven had become a staple at Rick Bayless's Chicago restaurants.

Warner and Hageman became interim managers in 2001 after long-timer Mary Carpenter stepped down. Their two years were packed with new initiatives: incorporation of the nonprofit Friends of the DCFM, a greater web presence, development of a weekly newsletter, expansion of an Info Booth and the establishment of an indoor Winter Market with breakfast by local chefs.

There had been a two-week holiday market at the Civic Center for years, but at the end of 2001, a larger winter farmers' market began at the Madison Senior Center with twenty-seven vendors. The following year, Monona Terrace Community Center opened its doors to DCFM for November and December, with the Senior Center hosting from the new year until opening day on the square so that the market is never entirely dormant.

The Taste of the Market breakfast has been an integral part of the Senior Center winter market from the beginning. For less than the price of brunch on the square, customers could enjoy a hot breakfast prepared by market-loving volunteers. In later years, the market breakfast became a gourmet showcase with meals from such local food notables as Underground Food Collective and Tory Miller, Odessa Piper's successor at L'Etoile.

The entire direct-to-consumer scene has experienced massive growth in the decades since DCFM started. Every spring, announcements of the opening day of market season seem to include more independent market locations. In the late 1990s and early 2000s, the community-supported agriculture (or CSA) model (where customers "subscribe" to a share of a farm's produce—basically Netflix for vegetables) also took off in popularity; in 2002, REAP Food Group began publishing the *Farm Fresh Atlas*, a directory of direct-to-consumer farms and markets that soon included dozens of farmers' markets throughout Dane County.

In 2005, the Northside Community Coop established the Northside Farmers' Market. This market was the first in the area to accept SNAP food assistance benefits as part of a USDA pilot program. Other markets, including DCFM, have begun exploring ways to accept food assistance benefits in recent years. Friends of the Dane County Farmers' Market provided a way for holders of electronic Quest cards ("food stamps") to buy "Market Dollars" for use on food and food plants at the market. The program was so successful that in 2011, Community Action Coalition for South Central Wisconsin, a large and active nonprofit, took over its administration, and nearly $50,000 per year are spent at the market through the program.

Community Action Coalition had also started a "gleaners" effort in 1992 to find volunteers to gather perishable food to share with area food pantries. Gleaners had been a regular fixture at the Wednesday DCFM since 1997, bringing extra produce to the Atwood Community Center. Most pantries are not open on weekends, making it difficult to store perishable produce after Saturday markets. Two key volunteers, Emmet Schulte and Ken Witte, met while gathering leftovers and eventually went on to manage the Madison Area Food Pantry Gardening Project. Witte especially did much to advance the gleaners' cause, gaining vendors' trust by establishing rules and demonstrating to pantries how much their users could benefit. He found donors for the gleaners' signature red vests and wheeled carts; impressed on volunteers the importance of courtesy, integrity and patience; and persuaded the food pantries to accept donations on Saturdays. Thousands of pounds of produce per week are provided in this way.

Schulte and Witte's story, along with dozens of other stories and farmer profiles, were included in Mary and Quentin Carpenter's book, *The Dane County Farmers' Market: A Personal History*. Published in 2003, the book chronicles DCFM up to the beginning of manager Larry Johnson's tenure and provides many examples of why DCFM has come to enjoy an international reputation. Invitations to share expertise and experience have come in "from Iowa to Italy," according to Johnson, who, in 2007, was named one of three finalists for Farmers' Market Manager of the Year from the North American Farmers' Direct Marketing Association. *Saveur* and *Midwest Living* are among the publications that have featured the market. Deborah Madison and Julia Child are just two of many famous fans who have sung its praises. Weekly attendance is higher than ever, new vendors can expect to wait five years for a spot on the square and downtown business hums with activity directly and indirectly brought by DCFM. "Everyone at the market listens to each other," Johnson said, which makes it a win all the way around.

LABOR
Unions, Just Dining and Dishwashers

The restaurant industry, being primarily a service industry, is greatly affected by labor issues. Location and cuisine, the employment rate, employee turnover and the nature of the staff at any given time all impact restaurant operations. Restaurant industry workers throughout the United States have from time to time sought to unionize, and this has certainly been true in Wisconsin in general and Madison in particular.

The Hotel and Restaurant Employees and Bartenders International Union (HERE) was formed in 1891 by workers in the hospitality industry. Smaller groups of cooks, bartenders and servers came together, especially gaining traction in larger cities. In the Midwest, HERE's influence branched out to Wisconsin and Minnesota and enjoyed an optimistic start in Milwaukee, enrolling four hundred cooks around the turn of the century.

The Madison chapter of HERE, Local 257, was active from 1936 until 1986. The union's first major action was the picketing of all 55 members of the Wisconsin Restaurant Association for the right to a closed shop, along with better wages and hours. In Madison, there were walkouts on Friday, June 19, 1937, at the Park Coffee Shop, Weber's, Cleveland's, Dodge's, Piper's Cafeteria and Jack's. Some city bartenders walked out in solidarity, and the truck drivers' and meat cutters' unions pledged their support. Asked how the eateries would stay supplied, a spokesman for the restaurants said they would go buy their own supplies or that "farmers might come to town" if all other options were blocked. Most restaurants reopened within a week, but the picketing boosted union membership by nearly 100, to a total of about 650 members.

In the late 1960s and through the 1970s, HERE was successful in organizing at some Madison restaurants, notably Shamrock (certified on November 1, 1969), La Crêperie (April 3, 1976) and Gargano's (February 16, 1977). The summer of 1970 also saw the revival of the Madison chapter of the Wisconsin Restaurant Association (WRA) under the leadership of several longtime restaurateurs, including Ed Lump of Brat und Brau, Alice Minnick of Top Hat, Gary Poole of Poole's Cuba Club, Pierce Nolan of the Congress and Bill Luther of Nob Hill. The WRA provided restaurant owners and management with shared resources and expertise, camaraderie and protection of their financial interests with a pro-business lobbying platform.

Though HERE Local 257 was gone by 1986, Local 150 of the Service Employees International Union (SEIU) took up some of the slack. Workers at the Concourse Hotel joined Local 150 in 1989.

While union influence had decreased, workplace concerns had not. So, on Labor Day 1999, the formation of the Interfaith Coalition for Worker Justice of South Central Wisconsin (ICWJ) was announced to address workers' concerns. ICWJ describes itself as "a coalition of individuals, religious congregations, interfaith bodies, labor unions, and community organizations concerned about economic and worker justice." Their mission is to bring the religious and labor communities together to provide education on labor issues and to support workers' rights. To that end, in 2002, the Workers' Rights Center (WRC) was established to directly assist workers who faced problems of documentation, discrimination and lack of information about their rights on the job.

The *Just Dining Guide* project began about a decade later, when the WRC found that a significant number of requests for its help came from workers in the restaurant industry. Pair that with the desire of many Madisonians to support businesses that treat workers well, and the idea for a dining guide based on working conditions was a logical next step.

The WRC mobilized volunteers to research and compile a new kind of dining guide that would highlight restaurants that provided good working conditions and benefits. WRC considered three audiences for the *Just Dining Guide*: the public, workers and employers. For the public, the guide helped point out where to eat while workers could use it to discover good places to work. For employers, the guide publicly praised those trying to do right by their workers.

The WRC knew that fairness and accuracy would be key to the project's credibility. The methodology was strictly comparative and quantitative. The guide presented objective data on starting hourly wage, health insurance, sick day pay, time off with pay, written records and retirement savings options and did not try to describe subjective experiences, such as workplace environment and morale. WRC volunteers did in-person and online surveys of employees, gathered data from employee handbooks and shared findings with the management of each restaurant before publication. Scope was also important. WRC decided to study only the area it defined as "downtown" in order to keep the project size manageable and to feature Madison's most popular restaurants.

The first edition of the *Just Dining Guide* was published in fall of 2012 and featured 139 restaurants, coffee shops and bars. As expected, it was met

with some criticism. A spokesman for the Wisconsin Restaurant Association was critical of the methodology in general and the introductory information in the booklet specifically (titled "Myths About the Restaurant Industry") and did not shy away from taking a point of view about labor issues. Some downtown Madison businesses took exception to the limited geographic scope, saying that it was unfair to small, independent downtown businesses to not include their corporate competitors further afield.

On the other hand, eaters, workers and many restaurants met the guide with enthusiasm. ICWJ and WRC staffers visited libraries, churches and community groups to distribute the guide and explain the project, receiving support and suggestions for improvement and future directions. On the business side, the Food Fight group discovered, when working on the guide, that some of their non-tipped workers hadn't been getting paid enough and rectified that. Management of Weary Traveler decided to contribute more to its workers' health insurance plans.

The second edition of the guide enjoyed higher participation rates by restaurants, covering 182 venues. A Spanish translation was made available, and an online app with a map and recommended restaurants went live in 2013. The third edition grew to 205 restaurants. In all three editions, some restaurants clearly stood out. Of the possible seven stars, only Ian's Pizza by the Slice on Frances Street got perfect scores all years. Other high scorers included Ancora Coffee, Amy's Cafe & Bar, Harvest, Restaurant Muramoto, Starbucks and State Street Brats.

This only goes to show that regardless of cuisine, price and size, many restaurants have found the sweet spot where success, fairness and quality are in balance.

DISHWASHING IN MADISON

Restaurants would not run without dishwashers. Carson Gulley and Jane Capito both started their kitchen careers washing dishes. One of the longest-tenured Madison restaurant employees on record, Oscar Huber, washed dishes at Smoky's Club for over fifty years. And at Dolly's Fine Foods on Williamson Street, Jackie Mackesey, the owner's daughter, shared her memory of the restaurant's dishwashers in the book *Madison Women Remember*: "We used to hire our dishwashers from the Madison jail. My mother would be delighted when she heard that one of her favorites had been arrested, because when they came out sober, they were hard workers."

Dishwashers also have an interesting history that intersects with labor issues in Madison, starting at the UW Memorial Union. Pete Jordan, aka "Dishwasher Pete," wrote an eponymous 'zine and, in 2007, published a memoir of his quest to wash dishes in all fifty states. Wisconsin was the twenty-second stop on his journey. Based on tips from his readers describing a kind of dishwasher's utopia of camaraderie and free food, he looked for a job "busting suds" at the Union. The job entailed cleaning up after food service from all over campus, and Pete found little of the glory he'd expected. The staff was disgruntled, and worst of all, scrounging was against the rules.

Pete asked around, hoping to find out about the glory days of Memorial Union dishwashing. After a trip to the Wisconsin Historical Society Archives, he discovered that there had once been a Memorial Union Labor Organization (MULO) and that dishwashers had been instrumental in its founding. MULO was established on April 9, 1971, and sought to address standard issues of working conditions and, because of the dishwashers' influence, scrounging rights as well. The union defended employees' prerogative to consume leftover, unserved food from catered events, food that would otherwise be thrown out.

Another crucial issue MULO confronted was a dangerous popcorn popper in the Memorial Union Stiftskeller. According to an undated press release with the headline "Student Labor Union Charges Popcorn Machine Dangerous to Health" in the archives, MULO urged Memorial Union customers to alert management that the poorly maintained machine was falling apart and posed a risk of electrical shock to the workers serving up bar snacks.

MULO enjoyed support from Local 257 and, in turn, wrote a letter of solidarity for the workers at Ovens of Brittany when they attempted unionization in the 1970s. In 1980, the organization suffered a blow when University Club disaffiliated from Memorial Union, and its employees were no longer part of MULO.

In the twenty-first century, MULO shrank considerably until its territory was basically a desk in the corner of the Teaching Assistants' Association office, and today, it is no longer active, despite a small bump in interest during the Act 10 protests of 2011. Nevertheless, "Dishwasher Pete" was still able to win back scrounging rights for himself and his colleagues by citing the MULO contract, thus ending his Wisconsin sojourn on a high note.

A HISTORY OF CAPITAL CUISINE

CAPITOL
Capitol Cafe to Savory Sunday

The capitol is Madison's most famous landmark, and it is hard to imagine what downtown would look like without a dome climbing into the sky. Certainly, many a Madison restaurant window has boasted a sumptuous view of that beautiful secular spire, and yet, until 1871, Madison had to fight to retain the seat of government.

Belmont was Wisconsin's first territorial capital. Madison won that distinction in 1837, thanks in large part to the lobbying of James Duane Doty, politician and land speculator. But for the next three decades, Milwaukee movers and shakers would periodically mount campaigns to woo the government to their city. As the largest city in the territory, it had the most financial wherewithal to lobby legislators with food, drink and smoke. Milwaukee would've likely won that fight if it hadn't have been for Dane County businessmen who, admitting Madison's lack of sophisticated hospitality, put up $100,000 to construct the Park Hotel. This state-of-the-art facility, opened in 1871, was located at 30 South Carroll Street but not before a squabble between "east side" and "west side" factions. Lucius Fairchild was instrumental in silencing the internecine fuss that might have given Milwaukee the upper hand. So the city of Four Lakes was selected and the placement of Wisconsin's capital was settled.

On January 10, 1917, a new legislature convened for the first time in the current capitol. On the same date, Elsa Kragh opened the Capitol Cafe in the basement of the building. Kragh had scouted a chef from Chicago and, within a few months, had transformed the basement into her own establishment.

For twelve years, the basement of the capitol was a hotspot. Having started with just a handful of lunch and dinner options for a dollar each, Capitol Cafe eventually stayed open on weekends and became one of Madison's most notable restaurants. Wisconsin's best and brightest—including Sophie Tucker; Harry Houdini; and his wife, Blossom Sealy—would visit to dine. Madison Prom was an annual dance held in the rotunda. On prom night, the Capitol Cafe served more than one thousand people.

In 1929, however, this chapter closed at the capitol. Between complaints of cockroaches and competition from the restaurants that ringed the square, dinners on the lower level ended just as the Great Depression started. A vendor on the first floor continued to serve snacks until early March 1938, when the *Wisconsin State Journal* reported:

Dwight Mack, superintendent of buildings, has banned the sale of sandwiches and coffee at the cigar and newsstand in the rotunda of the Capitol. Ice cream, soda pop, candy and gum remain. Doughnuts are gone, and so are potato chips…The crowd of hungry state employes [sic] who reported for work and then slipped down for a quick breakfast at the cigar counter probably looked bad to taxpayers. Health authorities, however, really were responsible for the order, Mack explained. He denied that cafe proprietors around the Capitol square had anything to do with it.

The article concluded that state employees ought to arrive having eaten and should be content with their ninety-minute lunch breaks. (Present-day state employees would like to point out that ninety-minute lunch breaks are as common as hodags.)

The state of Wisconsin was among the first states to adopt the principles of the Randolph-Sheppard Act of 1936, which gives blind business managers a right of first refusal for food services in government facilities. The act was amended in 1974 to extend to local governments, so when the

The basement of the capitol has been a café for members of high society, a lunchroom for civil servants and a warming place for the homeless.

capitol's cafeteria reopened in the 1970s, it benefited both blind workers and government employees in need of a fast lunch. The cafeteria remained open until after the turn of the last century, and though it no longer serves daily meals, it has become the winter home of a very special Madison event: Savory Sunday.

Savory Sunday started in 2005 with a plate of pancakes. Pablo Henderson, moved by anger in the wake of Hurricane Katrina to do something—anything—to alleviate some suffering, got together with a few friends and distributed breakfast food on State Street on an October night at bar time. This simple gesture snowballed into a weekly gathering at Lisa Link Peace Park. Volunteers fronted the food, and by January 2006, the Community Action Coalition was a major sponsor. Restaurants and the Dane County Farmers' Market also provided food for three hundred meals per week.

In the third year of Savory Sunday, Tom Barry, a local grilling enthusiast with an interest in environmental art, took note of how challenging it was for Savory Sunday to get a hearty entrée onto the table. Usually, plenty of bread and canned goods were available, but protein was scarce. This observation inspired him to get some friends together in the dead of winter and grill

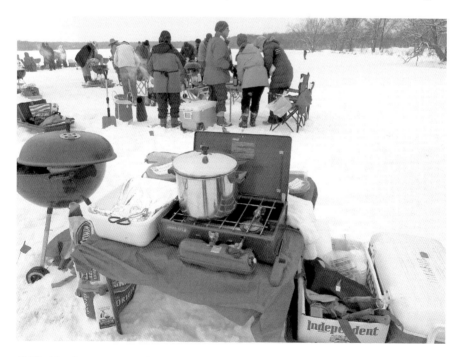

Grillin' for Peace attracts die-hards to a cookout on Lake Wingra on the first weekend in February.

meat out on the frozen waters of Lake Wingra. They arranged their classic Weber grills in a giant peace sign, and Grillin' for Peace began.

Locations for Savory Sunday shift with the seasons. James Madison Park is the current summer spot while the basement of the capitol serves in winter. This arrangement ran into some trouble in February 2011 with the Act 10 protests, when the Capitol Police Department began using the cafeteria as a staging area. Barry met with capitol police chief Charles Tubbs and Chris Schoenherr of the Department of Administration to advocate for Savory Sunday. In November 2011, permission was granted to come back to the capitol, and Tubbs and Schoenherr were among the volunteers at the first meal back under the dome.

Meanwhile, Grillin' for Peace had taken off. It tapped into Wisconsinites' love of tailgating and capitalized on the cabin fever that comes with late winter in Madison. The event attracts at least seventy grillers and often generates enough meat to furnish Savory Sundays through summer. Volunteers circulate and gather the extra goods, which are packaged and stored at the Lutheran Campus Center kitchen for use as needed in the coming months. Funds raised from reservation fees, T-shirt and raffle sales and additional donations also go to support Savory Sunday. The mood at the event is uplifting, and a spirit of neighborliness and joy makes Grillin' for Peace a warm success.

3

FARM TO TABLE FOR FOUR

OLD BUILDINGS, NEW RESTAURANTS

M uch of Madison's west side was verdant farmland as recently as fifty years ago. Three nineteenth-century farmhouses were converted into quaint restaurants in the 1970s and, today, are hidden at random among mall developments, fast-food parking lots and senior living centers. In many ways, the transformations of these buildings tell the story of Madison itself.

QUIVEY'S GROVE

The slogan of Quivey's Grove is "Other restaurants are in Wisconsin. Quivey's Grove is Wisconsin." The last three decades have proven that it is no idle boast.

The two restaurants that compose current-day Quivey's stand on land that was once part of John Mann's estate. Mann moved to Wisconsin in the 1840s from New York via Michigan (where he was a hotelier) and Illinois (where he ran a flour mill). His livery stable's success in Madison allowed him to build a sandstone Italianate mansion and a spacious stable in Fitchburg circa 1856. The mansion was home to at least five owners in its first one hundred years: Mann until 1876, then J.C. Latham until 1881, J.R. Comstock until 1935 and finally Hal Huddleston until 1948, when Dr. William Waskow and his wife, Margo, moved in. They raised horses and Afghan hounds, but in the late 1970s, the City of Fitchburg rezoned the property to exclude such activities.

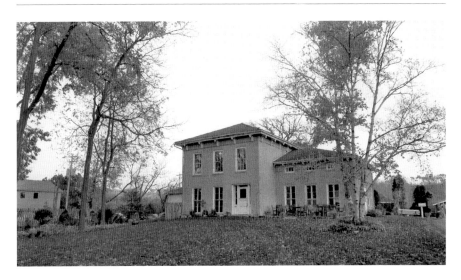

Quivey's Grove opened in 1980 and was on restaurant critic Dennis Getto's 1992 list of the top twenty-five restaurants in Wisconsin.

Fortunately, it was not hard for the Waskows to find a buyer. Joe and Deirdre Garton, young married professionals with four children, were in the market for a new home and were also interested in running a business of their own. At the time, Joe was teaching film history for the UW System; later in life, he was appointed chair of the Wisconsin Arts Board and was the driving force behind the successful restoration of Ten Chimneys, the historic Waukesha County home of Broadway actors Lynn Fontanne and Alfred Lunt.

The Gartons bought the Mann homestead from the Waskows in the spring of 1979 and enlisted the expert help of Arlan Kay to renovate the house and nearby stable into a restaurant and bar. Engineer James Kuenning also worked on the renovation and introduced his son, local cook and jack-of-all-trades Craig, to Joe Garton with the thought that Craig could lend a hand in the kitchen design. That began a happy partnership that endured for decades; Craig soon became a fixture at the restaurant and eventually co-owner with Joe and Deirdre.

Enthusiasm for history minus any stuffiness was a hallmark of the Gartons' approach. The name Quivey's Grove is a nod to Fitchburg's first inn, William Quivey's nineteenth-century roadhouse (about four miles east of Quivey's Grove, on County Road M at South Fish Hatchery Road), and the stand of trees in which the buildings are nestled. The restaurant's five dining rooms are decorated simply with period quilts, lithographs and wall

stencils. The Gartons also excavated a tunnel between the restaurant and the stable-turned-taproom to let people go from one to the other without the hassle of gearing up for Wisconsin winter.

The grand opening was on May 23, 1980. Reviewers praised the venue and the menu, which also took a playful approach to history. Kuenning and chef Paul Hellenbrand had set out to serve dishes that were never trendy yet not "period" either. They chose ingredients and cooking methods that would have been available to early Wisconsin settlers, and many recipes came from Joe Garton's family.

Fish fry was a given. Other dishes were named after historical figures—for example, Lamb Nolen, Veal Vilas, Beef Barstow and vegetarian Leopold's Feast. Over the years, the Quivey's Grove menu was tweaked, and to this day, every season sees a new variation.

Sharing was also part of the approach. Margaret Guthrie, compiler of the book *The Best Recipes of Wisconsin Inns and Restaurants*, included a few of Quivey's most popular recipes alongside contributions from Ovens of Brittany, Cafe Palms, Chez Michel, the Fess, Sunprint and L'Etoile. In a later collection, *The Best Midwest Restaurant Cooking*, she expanded her geographic scope, and L'Etoile and Quivey's Grove were the only two representatives of Madison's cuisine to make the cut. In 1994, Guthrie published the *Quivey's Grove Heritage Cookbook*, which included history and recipes.

The expansive grounds of Quivey's Grove also made it ideal for private and public events, and from the beginning, there were creative collaborations. On July 21, 1980, was Quivey's first "all you can eat, drink and dance" hoedown with live music. The Wisconsin State Historical Society began its annual Town and Country Antiques Sale there in 1987, and on September 20, 1989, Martha Stewart addressed a crowd of 450 of her early fans in what journalists later called her "only public appearance in Madison" before she hit the big time. Quivey's was in on the beginning of the resurgence of craft beer, as well; in the fall of 1994 was its first annual Beer Fest, and February 1, 1995, marked the first recorded "beer dinner" in the Madison area. The Quivey's culinary team paired menu items with Boston Beer Co. beverages; the first was so successful that three more dinners were held that summer.

In 1989, the Stable Grill was renovated, adding a full-service kitchen and using material mostly salvaged from other nineteenth-century barns. The Stable Grill offered its own menu of hot lunches and sandwiches, such as the Riley Reuben and, of course, the Fitch burger. Fish fry continued to be a popular choice; in 2007, Quivey's reported serving over 250 pounds of cod

every week, which it served on Wednesdays and Fridays in both the Stone House and the Stable Grill.

Of all the restored historical dining spaces in the Madison area, it's a safe bet to say that Quivey's Grove has best stayed the course. As an ad the restaurant ran in 1981 put it: "Reading about Quivey's Grove gets a little boring, eating there never does."

LA FERME, HOUSE OF HUNAN AND OTTO'S

At same time that Quivey's Grove was enjoying a careful restoration, another nineteenth-century farmhouse was undergoing a transformation. Johann and Donna Graffman bought Otto Toepfer's circa-1877 home at 6405 Mineral Point Road to open La Ferme. The project was not received well— one review pulled no punches, calling the surroundings unattractive and the Continental fare poorly executed and too expensive. La Ferme closed in 1981 after about a year in business. Its replacement, House of Hunan, holds the

Tasteful remodeling, an upscale menu and live jazz won a loyal clientele for Otto's when it replaced House of Hunan in 1987.

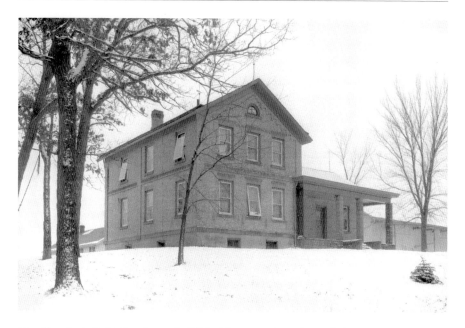

Otto Toepfer built his farmhouse in 1872. A barn stood nearby until the 1970s, and today, the lot is surrounded by modern development. *Wisconsin Historical Society, WHS-20832.*

dubious distinction of being the first restaurant to be shut down by the city of Madison Public Health Department. Things looked up in 1987, when Oregon high school pals Dan Johnson and Dave Bing opened Otto's. In 1996, Kamil Tanyeri (of Tanyeri Grill, a King Street favorite) and his wife, Dana, bought Otto's and melded its supper club vibe with Middle Eastern flair. They operated Otto's successfully until 2014, when they sold the restaurant to silent partners who promised to make few changes.

CHEZ MICHEL AND PIZZERIA UNO

Also on Mineral Point, what became, in 1991, Pizzeria Uno began as the Ganser farmhouse, built circa 1863. In January 1982, Michael Wilson opened Chez Michel there. Wilson contributed more than a half million dollars to the remodeling project. Architect Dave Cote envisioned a cozy bar area and an open dining room for the hilltop home. The menu was also upscale Continental. In 1985, Nancy Christy was called in to manage the second-floor Cajun Cafe, part of a wave of Creole cuisine that swept the

Pizzeria Uno replaced Chez Michel in the Civil War–era Ganser farmhouse on Mineral Point Road.

city and included New Orleans Take-Out and Da' Cajun Way. Downstairs, Chef Rymee Trobaugh took over to wide acclaim and went on to big things in San Francisco after Chez Michel closed in December 1990. Pizzeria Uno moved in after making some minor alterations; the deep-dish pizza chain had begun on North Wabash Avenue in Chicago, and the first Madison location on Gorham had done so well with students that Madison gained a second before Milwaukee even saw its first. Indeed, it supplanted Rocky's as Madison's favorite pizza in *Madison Magazine* and *Isthmus* polls until the arrival of Glass Nickel in the late '90s.

COBBLESTONE STATION, ANNEX/WASHINGTON POST/ HOST AND FYFE'S

The cream-colored brick building at 1344 East Washington Avenue is another example of a recycled nineteenth-century building. Though not a former farmhouse like Quivey's Grove, Otto's and Pizzeria Uno, it once housed the Depression-era Wisconsin Transient Bureau and, before that, the

Fuller and Johnson Co. farming implement firm (whose plows were also sold at the Plow Inn, hence the name). In 1973, Craig Mengeling and his wife, B.J., turned the space into Cobblestone Station. Mengeling, originally from Stoughton, had gained some food service background at university catering jobs. Also an avid antiquer, he decorated lavishly from his own collection and most often wore a tuxedo while hosting (always a rarity in Madison). Popular for its surprisingly inexpensive spaghetti dinners and fish boils, Cobblestone Station was nevertheless short-lived.

In 1977, it was replaced by the Annex, later called the Washington Square Annex. It was during this era that the circular bar, originally built in 1933 for an establishment at the Chicago World's Fair, was moved in from Inn on the Park. It closed in 1992 after two more name changes (Washington Post and then Washington Host after the newspaper objected). The next owners had a fine culinary pedigree. Susan Breitbach came from the Barber's Closet in the Hotel Washington, and there had met Keith Blew from the Fess. They opened Fyfe's Corner Bistro in 1993. Fyfe's served up a white tablecloth experience in a bright, high-ceilinged dining room for fourteen years; it was an especially popular site for election-night parties. Fyfe's closed in 2007, and Blew went to Talula, a rambling building off Cottage Grove Road that originally housed a Henry VIII–themed restaurant, then the Pig's Ear supper club, then CJ's (the last in its mini-chain) and finally Mexicali Rose. Talula kept the color and tried to attract a hip crowd with bike path access, live music and funky décor, but the food didn't pull its weight; Talula closed and remained vacant for several years.

Fyfe's, too, stood fallow until, in late 2014, Pasqual's announced plans to move in and open a new incarnation of their venerated New Southwest restaurant.

4
SEVENTY-SEVEN YEARS AGO

MADISON'S MOST ENDURING EATERIES

I t would be easy to think of Madison as all new buildings with little history, given its large student population and perpetual construction. In this chapter, restaurants and buildings that have weathered the last eight decades with aplomb are highlighted. Those still in operation are worthy of a visit on both historical and culinary merits.

KENNEDY MANOR

Kennedy Manor Dining Room enjoyed a long tenure in the basement of the apartment building of the same name at 1 Langdon Street, "Madison's smartest address" since 1929. Kennedy Manor, Langdon Hall (633 Langdon Street) and the Nurses' Dormitory (1402 University Avenue) were all designed by architect Frank S. Moulton. Their construction marked a shift in student housing trends toward dormitories and small private apartments. Previously, students mostly lived in fraternities, cooperative houses or rooming houses in the low-income "Latin Quarter" of town near the east end of University Avenue. As such, they were received enthusiastically. An advertisement placed in the *Capital Times* on May 25, 1930, by Drs. T.F. and G.F. Kennedy urged potential tenants to snap up apartments vacated by the students, boasting that Kennedy Manor had been fully booked long before the building was completed in the fall of 1929.

Kennedy Manor, built in 1929, was in the vanguard of a new type of student housing. *Wisconsin Historical Society, WHS-3279.*

Kennedy Manor also operated as a hotel, and its apartments did not all have kitchens. Therefore, a dining room was essential, and it developed a reputation for elegance. Throughout the 1930s, the Kennedy Manor Tea Room got frequent mentions in the society pages and was in near-constant use for weddings and social club luncheons. In 1934, Nora Peterson joined the staff and stayed on for over forty years. A 1977 newspaper profile of Peterson described how she started working in hospitality management with her aunt, Clara Lauck, at the Nakoma Country Club. Peterson's banana bread, pecan rolls and eggless date torte became signature dishes. She also served on the board of the Wisconsin Restaurant Association for eighteen years. In 1968, she retired and her son, Lyle Peterson, took over. But living upstairs from her old stomping ground proved boring, so she came back to work in 1972.

By the 1980s, Kennedy Manor had hit a rough patch. The 1983 guidebook *Beer Drinking in Madison* gave this colorful description of the bar, which was still serving sandwiches: "Walls covered with naugehyde [*sic*], ancient wallpaper, and duct tape; atmosphere is similar to that in some of the older college bars

in New Haven, and let's hope it is never remodeled as this is a classic joint for sitting around and loading up."

Around 1987, Chuck Taylor bought Kennedy Manor Dining Room and made an effort to bring back the classiness. Taylor, owner of the Flamingo Bar on State Street until 1998, was a former math teacher and director of the Greater Madison Convention & Visitors Bureau who got his restaurant experience at Laurel, Rohde's, Esquire and Irish Waters. He changed the name to One Langdon, but by 1989, he had decided that Kennedy Manor's name recognition was more important. Despite positive reviews and modest success, he decided to close in 1992. In 2005, he took over Blue Marlin from Finn and Chris Berge.

The 1992 closing of Kennedy Manor was perfect timing for Andrea Craig and Nancy Christy. Having succeeded with the Wilson Street Grill, they wanted another project, preferably one that would repurpose existing restaurant space in a saturated market. Kennedy Manor appealed to them for its sense of place, and they put in quite a bit of sweat equity to refurbish the dining room to its former Art Deco elegance. In August 1993, Kennedy Manor reopened. Soon, chef Anne Breckenridge's focused European menu was gathering rave reviews.

At the end of 1999, Craig and Christy wanted to move on. Their Wilson Street Grill protégé, Dawn Parker Theisen, and her husband, Mark, took over, and after some hiccups and a new chef (Perry Sheldon of Coyote Capers and Otto's), they hit their stride. The menu has remained quite consistent, with small seasonal changes but always classics like mushroom risotto and Caesar salad.

Chef Ben Smejkal and the Theisens continued the legacy for several more years. During their tenure, Kennedy Manor Dining Room received amazingly consistent reviews. Whenever a new report appeared, whether an online rating or in the professional press, the tone was usually one of wonder that a nice place like Kennedy Manor remained under the radar. In October 2014, the Theisens announced that they were planning to retire and closed Kennedy Manor soon after.

CLEVELAND'S

Easily overlooked on East Wilson Street stands Plaka, a small restaurant established in 2008. For lunch and dinner, it serves what you'd expect under a sign that says "authentic Greek taverna"—gyros, spanakopita and

Plaka opened at 410 East Wilson in 2008, just shy of what would have been Cleveland's 100th anniversary.

avogolemono soup—and serves it very well. But come here for breakfast, and you will find a tribute to one of the oldest eateries in the city, Cleveland's.

Ulysses Orlando Cleveland opened Cleveland's Lunch Room about 1909 in a tiny building at 410 East Wilson Street. Prior to Cleveland's, it had housed a barbershop and then Louis Hess's fruit, candy and cigar shop. In Madison's railroad heyday, Cleveland's was open twenty-four hours a day because of its prime location between the excitement of King Street and the Chicago & Northwestern Railroad depot on Blair Street. Orlando and his wife, Meltha E. Andrus Cleveland, ran the place for four decades and employed a number of interesting local characters.

In the 1930s, when two hamburgers, potatoes and milk cost thirty cents, Horatio F. Guernsey and Theodore G. Mueller held down the fort. Guernsey was an influential HERE Local 257 member who worked at Cleveland's for twelve years and died while at a union meeting in 1942. Mueller was well loved. *Wisconsin State Journal* publisher and editor A.M. Brayton wrote on July 9, 1933: "My distinguished respects to Ted Mueller of Cleveland's Lunch. Everything is good at Cleveland's Lunch, and old-timers know the delight of chatting with this once famous army cook when he drops into a reminiscent

In 1918, East Wilson Street offered travelers lodging and food at the Cardinal Hotel and the Lake View Hotel and Quick Lunch. *Wisconsin Historical Society, WHS-55076.*

mood. Perhaps some people do not know all that is nice about Cleveland's Lunch, but I do—from cellar to garret of the tiny shop."

Cleveland's wasn't all nice, all the time, however. In 1935, it housed one of three city-licensed "pinball" machines caught illegally paying out money. The other two were at Campus Soda Grill, 714 State Street, and Jack's, 814 University. It was also involved in the restaurant workers' strike of 1937. For a few days in June, workers walked out, and Cleveland's was closed for the first time since Orlando died in 1928. Meltha denied rumors that Cleveland's was closing permanently. Indeed, she continued to run the restaurant until the building was condemned in 1951. The city granted Meltha until the spring of 1953 to close or move out, but by November 1952, Cleveland's was done. Meltha died on November 28, 1952, leaving the business to William Anderson.

Anderson rebuilt Cleveland's and reopened to little fanfare around 1954. By that time, the railroad was no longer a vital economic force and that section of Wilson Street had basically become "skid row." Anderson and his wife ran a clean restaurant, always caring for the neighborhood and taking a two-week break every August. Cleveland's was known as a fair place to redeem a Salvation Army meal ticket and rarely turned anyone away. In 1967, Quentin Braun started as a cook. In August 1971, when William Anderson took his last vacation, Braun was there to reopen, ushering in a new era for Cleveland's.

At that time, Cleveland's was one of the only places to get an early breakfast in Madison. It began to attract a mix of the usual down-at-heel characters but also frugal students and downtown suits. For two days in 1974, it even employed an assistant district attorney, James Crandall, as dishwasher before his boss insisted he quit.

Meanwhile, over on Williamson Street, another greasy spoon called Dolly's Fine Foods was doing double duty as a radio studio. In 1978, Michael Feldman, then a volunteer host for WORT 89.9 FM, started broadcasting his weekday morning *Breakfast Special* from Dolly's dining room. Feldman interviewed the staff and customers, and community groups came looking for a chance to plug their causes on WORT's most popular time slot.

After Feldman quit *Breakfast Special* in 1979, the show moved to Cleveland's. It stayed there during ups and downs (and several hosts) through the 1980s. Notable hosts included musician Ken Lonnquist, who even recorded an album called *The Late News From Cleveland's Lunch*. *Breakfast Special* was a popular but expensive show for WORT to run. By 1990, it had more or less petered out but not before sowing the seeds of another WORT institution, Friday afternoon's *Mel & Floyd's Summer Replacement Show*. John Fields ("Mr. Smarty Pants") was working at Cleveland's and would hang out with Ken Brady ("Mel") and Peter Johnson ("Floyd") before the restaurant opened. Eventually, Fields and Brady hosted their own studio show riffing on current events and whatever else struck their fancy.

Despite doing a good business, it was time for Quentin Braun to retire, so in 1992, Cleveland's Lunch closed again. At the same time, the 1990s saw a rise in Madison nostalgia for diners like Cleveland's, surging just before many of the classics closed up shop. Bob's Blue Plate Diner (Monty's original moniker) led the repackaging of the genre. Mickies and the Curve made it through the pinch, and Dinner Bell at 44 South Fair Oaks Avenue changed hands (first as Curve II and then Fair Oaks) but remained a diner. American Lunch at 1033 South Park Street had been open at least fifty-eight years before closing in the early 2000s. Its 3:30 a.m. opening time meant it was there for UW security guards and Bancroft dairy workers. Linda's, in Middleton at 7457 Elmwood Avenue, ran from 1972 to 1989 before becoming the more polished Bavaria Family Restaurant. And Bev's at 2422 Winnebago was established in 1971 by Beverly Dunn Philumalee. Its Saturday special of chipped beef on homemade bread was a hit, and it was one of the first restaurants in Madison to have a website. Still, in 2000, Jason Dunn, Bev's son, moved the restaurant to a banquet hall in Marshall, where it had a short run. Bev's became briefly Trudy's Cafe, another diner,

but today, the site is part of a vacant area long slated for redevelopment. Bev herself passed away in 2015, but some of her recipes live on at Harmony Bar on Atwood Avenue.

Back on Wilson Street, developers Todd McGrath and the Sveum brothers, with architect Ed Linville, started making plans to renovate Cleveland's building. Brothers Telly and Nico Fatsis reopened it as Cleveland's Diner in April 1995. Telly, a native Madisonian, had recently returned from Texas. His job at the Parthenon took him past Cleveland's every day, and being a fan of old-school diners, he dreamed of running his own. So he and his wife, Beth, kept the classic Cleveland's menu at first. They also became owners of the Athenian Garden food cart on Library Mall. In 2006, they opened Atlantis Taverna in Sun Prairie, inspired by Telly's family connection to the Peloponnese region of southern Greece. In 2008, the success of the Greek menu at Atlantis led to Telly's remodeling Cleveland's and renaming it Plaka. He kept Cleveland's early breakfast hours and still serves diner classics. In the right light from a seat by the front window, customers can look out over their pancakes and glimpse Lake Monona from one of the most storied eateries in the city.

THE FESS HOTEL

A little way up from Cleveland's, Wilson Street forks into King Street. Just off King is the Great Dane, formerly the Fess Hotel.

George E. Fess, originally Face, was a shoemaker from Gloucester, England, who came to Madison in 1842 after some years as steward on a Lake Michigan steamer. He got work at the American Hotel on Pinckney Street, the busiest commercial area of the city. His wife, Anna Rossbach, immigrated to Blue Mounds from Saxony in 1847, and they were married in 1853. Some accounts credit Fess with being caterer to Leonard Farwell, Wisconsin's second governor (1852–54). In any case, by 1854, George was a successful entrepreneur operating the Old Hickory House at South Webster near Main Street. The *Daily Wisconsin Patriot* announced the eatery with a notice that George was "Old Hickory to the back bone on the go-ahead principle," and being that the Patriot's motto was "Be sure you're right—then go ahead," it's likely they meant it as a compliment. George's character also shows up in his Old Hickory ads: "The subscriber tenders his services to all his old and new friends, as well as enemies, if he

On October 6, 1975, the Fess Hotel was designated a historical building by the Madison Landmarks Commission. After the Fess closed, the Great Dane moved in.

has any, at his Stand near Ott & Griffith's Store, Madison. He constantly keeps on hand everything good in the line of Eatables and Drinkables! No pains spared to accommodate all customers, in due season, and in 'apple pie' order."

Fess was on the way up. In 1856 (some earlier assessments said 1859), he started building the Fess Hotel on Clymer (now Doty) and Webster Streets, which was to be a family business for the next three generations. The structure was built in three sections: a wing of salmon-colored brick on the corner, rooms with Cream City brick farther up the street and the extensive stables that cemented the hotel's regional reputation. Mrs. Fess's cooking also helped, as did a charming walled garden between the hotel and the stables. George Jr. came along, and when he was old enough, he worked at the hotel as a clerk.

In 1875, George Sr. died, and his family continued to operate the hotel. Around 1900, the hotel hosted Carrie Nation because it was one of the only temperance hotels in the city—which is to say, in a downtown rife with saloons, it had no bar. It came to be known as the "Central Hotel" and was remodeled in 1901.

Meanwhile, George Jr. married Delia from Beaver Dam, and their daughter, Marie, was born. Delia was quite accomplished. She was a charter member of the Woman's Club of Madison, and when George died in 1923, she oversaw the hotel's 1924 expansion to seventy-five rooms. Ten years later, Marie Fess married Thomas Spence, who joined the family business. Marie went for a master's degree in organic chemistry and taught at UW–Madison. They lived in a spacious lake-view apartment on the top floor of the hotel. Delia passed away in 1945, by which time the stables had been razed, and in 1957, a city parking lot was erected on the site. Throughout the 1950s and 1960s, the Fess continued to operate as a hotel and ran a modest café for travelers and downtown workers. By the early 1970s, it was showing its age. In 1971, Thomas Spence died, and Marie put the hotel on the market. It was purchased in 1973 by real estate developer Donald Hovde.

This was perfect timing for a revival. About a year after Hovde bought the property, a group of three energetic partners calling themselves "Arabesque" (Mary Bergman, Peter Wright and Norwood "Woody" Kneppereth) undertook a major renovation. They engaged help from architect Arlan Kay and oversaw the work themselves. Their dream started small—just a modest, nice eatery to ride the new wave of energy that had started in downtown Madison restaurants—but eventually grew to include a two-story restaurant with two bars and a completely restored garden dining area. The bars were open by November 1975. Restaurant service started within another month.

And the food was a hit. Herbert Kubly, the *Milwaukee Journal* reviewer, observed that "Madison's stature in fine dining has been earned by young people," citing the youthful staff of Ovens of Brittany, L'Etoile, Athens and Peppino's as evidence of a new generation of food in Madison. He also praised the Fess's Belgian chef Omer Gondry, whose Continental cuisine showed off his skill as a master saucier. The other three partners were highly educated but had somewhat less experience in the food business. Kneppereth had done some bartending, Wright had once worked in his father's coffee shop and Bergman had a master's in public health and nutrition from the University of California–Berkeley. What they lacked in experience they made up for with energy, and the city appreciated their work.

The Fess's patio became a hotspot for a new trend, brunch, where pre-noon liquor sales were snuck by in mimosas and Bloody Marys. By 1978, there were far more places offering the now ubiquitous midmorning meal, among them other hotels like the Cardinal, Concourse, Ivy Inn, Sheraton, Top of the Park, Admiralty Room at the Edgewater and Barber's Closet at the Hotel Washington; semi-suburban spots, such as the New Orleans Chart

House and Toulouse St. Wharf, Minnick's Top Hat, CJ's Town House at Westgate Mall and the Left Guard Steak House on East Washington; and hip spots like La Crêperie on State Street.

By the 1980s, the Fess was established as a watering hole for musicians, journalists and politicians. It's said that Hizzonner Paul and Sara Soglin had their first date at the Fess. The Spences' former home had been renovated into offices, including space for *Madison Magazine*, whose editors and friends (including *Wisconsin State Journal* columnist Doug Moe) often camped out at the bar.

The fare continued to get good reviews, especially the "fondu parmesan," described variously as a breaded, deep-fried blend of cheeses served with fried parsley or as a large piece of baked gruyère, flavored with white wine and seasonings. Either way, a Madison bar can never go wrong with hot cheese. In the later '80s, even the Fess lightened up, adding a "Fess Express" grab-and-go lunch service that touted fresher fare and more local produce.

The Fess's last day was Sunday, June 26, 1994. The two remaining partners, Woody Kneppereth and Peter Wright, announced that they had decided to sell because the time was right to do it before they had to. The announcement was greeted with a cry of sadness and one last whoop from the Fess's regulars, who were invited to take barstools home from the farewell party. The buyers were two native New Yorkers named Eliot Butler and Rob LoBreglio, who were looking to open a brewpub. They scouted Madison as a promising site and opened the Great Dane a few months later; it was a good move. Two decades later, the Great Dane operates four Madison locations and one in Wausau, and its protégés opened their own craft breweries in turn. Complementing house brews with good food has become de rigueur for Madison brewpubs, which, like Old Hickory, try to stock everything good in the line of "Eatables and Drinkables."

SIMON HOTEL

On South Butler Street, just a few hundred feet north of the Great Dane (as the crow flies), stood the Simon House, a storied Madison locale that enjoyed two golden eras of hospitality. The first was from 1883 to 1921, when it was a celebrated hotel and restaurant; the second was from 1952 to 1971, when it was in the vanguard of Madison politics and culture.

John Simon was born in 1831 in Cologne, Germany, and immigrated with his father in 1845. They settled in Springfield Corners northwest of Madison, not far from his future wife's home in Roxbury. Helena Lamberti (or Lambardy) came from Alsace-Lorraine with her sister and made the one-hundred-mile journey from Milwaukee to northwestern Dane County on foot.

By 1850, they had moved to Madison, where John found work at a brickyard for a few years before joining the Rodermund Brewery (later home to the Hausmann Brewery). After nine children and an eighteen-year career, the Simons retired but found it dull, so in 1873, they took over the hotel Germania House on East Wilson Street. Mrs. Simon was known as a great cook, and the business flourished. Ten years later, John Simon decided to build his own hotel at 107 South Butler Street. Fellow German immigrants Bruno Kleinheinz and his wife (whom Mrs. Simon had hired for the kitchen) took over the Germania.

The Simon Hotel opened in 1883, and the senior John Simon ran it until two sons, Fred M. and John, took over in 1895 (or 1898); Fred and his wife assumed operations from 1914 to 1921. The Simon's location was handy to City Market and the capitol, making it a popular spot for merchants and rural legislators. The dining room served up to a thousand meals per day and was particularly celebrated for its Sunday dinners: all-you-could-eat, family-style fare from soup to meats, potatoes, relishes and pies, all for thirty-five cents. Understandably, the Simon was patronized by students, travelers and families, as well as a "who's who" of Madison movers and shakers, including Oscar Rennebohm, William T. Evjue and Vincent Kubly.

The Simon family sold the hotel in 1921, and from then, a "succession of other hotel men" ran it until 1939. Albert M. Ophaug was the last of them, and when he retired, Mrs. Simon and her daughter, Lucille Schaub, bought it back from him. But the dining room had ceased service during Ophaug's tenure and hadn't yet made a comeback.

It was the memory of the old dining room that inspired Deane Adams and Maurice Combs to lease the Simon in 1952 from Fred M. Simon's estate. Adams, with a passion for elegant design, and Combs, the head chef at UW Memorial Union, dreamed of bringing the Simon back to its prime. And for almost three years, they succeeded; the papers applauded the return of fine food and service in three opulent dining rooms. Tragically, on February 10, 1955, the three-story building was destroyed by fire. Two employees living on the top floor survived by leaping from a fire escape, and the damage was estimated at $150,000.

Undaunted, Adams and Combs cleaned up the mess and reopened the restaurant on January 18, 1956. Though just one story now and with its majestic fifty-year-old trees gone (killed when they were encased by ice from the water used to extinguish the fire), it came roaring back in a big way. The Continental fare was fairly unique in Madison but also garnered national praise. For ten years starting in 1957, Simon House won the *Holiday* Restaurant Award, presented by the esteemed travel magazine to the best restaurants in the United States.

Also unique in Madison was Simon House's extensive art collection. John Hunter wrote in the *Capital Times* of May 26, 1959, that "Madison does not have an art gallery, but the nearest thing to one is at the Simon House Restaurant." The walls of the dining rooms served as a profitable place for local artists to show and sell their works. Adams also had an interest in circuses, and so a number of lithographs from the Wisconsin Historical Society's Harry A. Atwell Circus Collection were among his favorites.

In 1962, the Simon House Bakery opened at 115 South Butler. By bringing on Rolf Muenn and Helmut Richter, two graduates of a bakery trade school in Germany, the European credibility of the Simon was boosted. This was the second golden era. Yet trouble was on the horizon. In 1968, James W. Lyman and Joe Troia took over management of the restaurant from Adams, and by 1971, Lyman was listed as the owner when reports came out detailing the Simon House's closure by the feds for not paying its taxes.

There was a short-lived attempt to revive the Simon House. Anthony and Maxine Sanna, new restaurateurs who had recently opened the French Quarter at 3520 East Washington, reopened it in March 1971 as Anthony's Simon House. They kept the traditional Continental menu, but quite a bit of momentum had been lost, and the place seemed stodgy compared to the new generation of restaurants popping up. Both the Sannas' ventures went bankrupt in 1973.

In the summer of 1974, Anthony's Simon House became Blue Max, a more casual eatery run by four Air National Guard pilots. While the novel aeronautical theme appealed to some, it wasn't enough to keep Blue Max aloft; it closed in 1975, and the once elegant Simon House was converted into office space.

THE STAMM HOUSE

The final stop on this tour of places from seventy-seven years ago is not in Madison at all. Dane County's oldest tavern stands at 6625 Century Avenue in Middleton. Its colorful history is that of the Midwest in miniature. The Stamm House, as it was known for most of the twentieth century, was built in sections over five years, opening in 1852. As the Pheasant Branch Hotel, it was many things to travelers and residents of the young city, including a post office, tavern and stagecoach stop (though the coach horses were often put up a half mile south at the site of the current Club Tavern on Branch Street because the low ground bred too many flies). A tunnel leading toward the marshy creek became a hiding place and escape route for fugitive slaves on the Underground Railroad. The hotel closed in 1910, and in 1920, the second floor was turned into a community gathering place and library. Meanwhile, another part of the building hosted a speakeasy, reopening as a legal tavern in 1933 and serving twenty-five-cent chicken dinners by 1936. The beginning of its famous Friday night fish fry came in 1940.

The Fuller family had a hand in the Stamm House for three decades. Herbert Fuller, a veteran of World War II, ran the restaurant from 1945 to 1960. Les Moller took over in 1960, but Fuller's niece and her husband, the

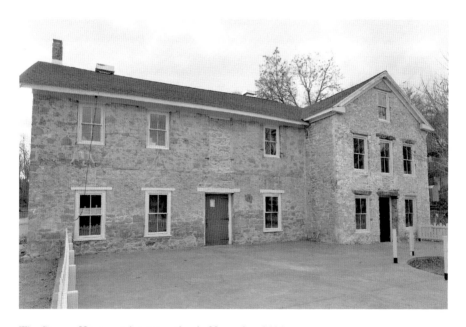

The Stamm House, under renovation in November 2014.

Pohlkamps, operated the dining room. On April 1, 1970, a prominent Madison restaurant couple, Jim and Mary Sweeney, bought the Stamm House for another long tenure. Summer 1995 saw another change of hands, to Irish Waters operators Jeff Bunge and Donna Small. Despite being all the way out in Middleton, the Stamm House was a regular competitor for Madison's best fish fry, though it usually lost to Crandall's or the Avenue Bar. Always popular (but sometimes seemingly staid and stale), Stamm House closed abruptly in the spring of 2013. Realtor Troy Rost scooped up the property and announced plans with chef Nick Johnson (of Restaurant Magnus and 43 North) and Brian and Alicia Hamilton (of Weary Traveler) to rejuvenate the property and bring it back as a modern Wisconsin supper club.

5
SOUL PROPRIETORS

African American Restaurant Owners and Chefs

S tories of successful eateries and beloved personalities from Madison's African American community go back to the beginning of the twentieth century. Restaurants and other businesses run by black entrepreneurs tended to find more success in prosperous decades. During the Roaring Twenties, when the black population was about three hundred, Hoover's in Middleton, Oliver Davis's in Monona and Mosley's downtown tamale cart were known as great places to eat, and Carson Gulley was on his way to becoming Madison's first celebrity chef. Gulley's fame peaked in the 1950s, but his success didn't exempt his family from housing discrimination. Similarly, the 1960s brought the end of the Greenbush neighborhood; black-owned businesses, particularly Trotter's Tuxedo Cafe, overcame many difficulties when they were forced to relocate. Since then, many African American and soul food restaurants in Madison have come and gone. Most have been short-lived, with the exception of Purlie's, which was an important part of the community for two decades.

HILL'S GROCERY

The neighborhood on East Dayton Street between North Blount and East Mifflin was the center of Madison's first black community. Among its early residents were William and Anna Mae Miller. William Miller was an attorney

who hailed from Tennessee. While waiting tables at the Plankinton Hotel in Milwaukee, so the story goes, Miller's sharp wit was noticed by Governor LaFollette, who invited him come to Madison. Miller worked for the governor's office, though racial discrimination prevented him from practicing law; similarly, Anna Mae's training as a teacher was no help to her after William died because she was not allowed to practice her profession. So Anna Mae rented out rooms and did odd jobs to make ends meet. Many decades later, their grandson Greg Johnson, proprietor of Bon Appetít Cafe at 805 Williamson Street in the 2000s, was born in the Miller family home. Another culinary connection was chef Ernest Mitchell, who married into the Miller family. Mitchell, a 1933 graduate of Central High School, cooked for the Pi Lambda Phi fraternity and worked for several local restaurants.

William and Anna Mae Miller donated land at 631 East Dayton for St. Paul African Methodist Episcopal Church, which was founded in 1902 when the black population of Madison was about 140. A sesquicentennial plaque stands at the corner of Blount and Mifflin Streets commemorating the neighborhood's rich history and pointing out the connection between the church and Hill's Grocery. The plaque says that John Hill moved to Madison from Atlanta in 1910 and bought the grocery business from a pastor at St. Paul's in 1917. According to the 1972 *NAACP Black Book*, an account of the black community in Madison, Hill moved to Madison in 1905 and opened the grocery store on November 23, 1915. Either way, the Hill family operated the grocery continuously until 1972.

HOOVER'S

Frank Hoover was born in La Cygne, Kansas, and moved to Madison in the first decade of the 1900s with his wife, Laura. Frank had cooked in the dining cars of the Union Pacific and Santa Fe Railroads and, in Madison, was a chef at the Elks Lodge and the Maple Bluff Country Club. There, he worked with Harry Allison, the ice cream maker at Mansfield Ice Cream Shop on Monona Avenue. Allison stuck to catering and country club work while Hoover struck out on his own. In 1911 (some accounts say 1916), Hoover leased the building at 1915 Branch Street in Middleton, which at the time was owned by Felix Duschak and known as Ye Old Tavern.

Club Tavern once served the same coach lines that Stamm House did. The two are about a half mile apart.

Hoover set up a restaurant in a former railroad car in front of the building, and his cooking, already popular with the businessmen of the area, appealed to a broad audience. Despite this, when Hoover tried to buy the building, racial discrimination prevented him from doing so. In 1917, he rallied customers' support to build his own restaurant a bit north of Ye Old Tavern on Parmenter Street. Though his new place went by various names, including the Auto Club, the Old Middleton Roadhouse and the Pines, most people simply called it Hoover's. Laura was an equal partner in the business, with her own reputation as a good cook and a great shot as a rabbit hunter. Frank died on April 8, 1930, and Laura tried to continue the business despite financial problems. Ultimately, Laura sold it, and the Pines went on to enjoy a typical supper club career, changing hands several times before closing and succumbing to redevelopment.

Ye Old Tavern never closed, even during Prohibition. Built as a boardinghouse sometime between 1860 and 1880, it had many owners after Hoover's departure. In 1981, James "Moose" Werner took over and has run the Club Tavern bar and restaurant since.

OLIVER DAVIS'S

Across town, Oliver Davis operated an eponymous restaurant and club near Esther Beach in Monona that became famous for steaks and chicken dinners in the 1920s and 1930s. Davis's father, Logan of Louisville, Kentucky, was born into slavery. Oliver was born on September 9, 1876. In 1922, he bought the property, which included a building dating back to 1854, near Lake Monona. After years of restaurant success, Davis's business closed, and the building was demolished for construction of houses and the Beltline highway sometime after 1950.

MOSLEY'S TIA-JUANA HOT TAMALES

A gossip column item in *Capital Times* on January 22, 1924, mentioned a conversation overheard on University Avenue between the "Hot Tamale man" and "portly Frank Hoover of chicken dinner fame." Apparently, the friendly razzing took the form of an argument over which meat was better suited to tamales, chicken or beef. It can be surmised that the "Hot Tamale man" was either John Scott Mosley or his employee, William Pearl. Mosley operated a barbershop at 732 West Washington where he also did the prep cooking for his food cart. The Tia-Juana Hot Tamale cart had a circuit up and around the Capitol Square, down State Street and south on Park Street back toward the Greenbush neighborhood. Mosley's beef tamales and hamburgers smothered in meaty red sauce were legendary. It's likely that his version of tamales—described as "a Spanish and peppery sandwich" in the *Capital Times* of November 1, 1931—were the kind that crossed into Mississippi Delta cuisine with migrant workers in the early twentieth century and then came to the Midwest with northward black migration.

CARSON GULLEY

Carson Gulley was Madison's first celebrity chef and also a civil rights pioneer. His work at the University of Wisconsin and Tuskegee Institute and his own catering business and community work blazed a trail for African Americans in Madison in the areas of media, employment and housing.

He was born in 1897 in Zama, a rural Nevada County town in southwest Arkansas. His parents were sharecroppers who valued education and encouraged their son to succeed. He got a better education by apprenticing with a secondary teacher. He became a teacher himself, married and had four children, but that marriage didn't last. Tired of teaching and farming, he moved to Eldorado, Arkansas, and worked as a dishwasher. He then went on to restaurant jobs in Kansas, Florida and New York. In Kansas City, Missouri, he became the pastry chef at the Baltimore Hotel and later was the chef at the Christian Science Principia Institute in St. Louis during the school year, with summers at the Essex Resort Lodge in Tomahawk, Wisconsin.

The Madison chapter of Gulley's story began in the summer of 1926. Donald L. Halverson, the director of Dormitories and Commons at UW, was passing through Tomahawk when a thunderstorm waylaid him. Stopping in at the Essex to find the kitchen already closed, he asked if someone could rustle up a sandwich. Instead, Gulley prepared a full meal. This so impressed Halverson, who learned his lifelong appreciation of fine cooking from his culinary-trained mother, that he invited Gulley to visit with him after the meal. The visit turned into an invitation to an early morning fishing trip the next day, then lunch, then another dinner and finally Halverson asked Gulley if he would be interested in working for him. Gulley began his twenty-seven-year career at the university in December 1926.

In 1930, he married Beatrice Russey, also an Arkansan and a former schoolteacher. They faced housing discrimination in several neighborhoods and had to move often. According to Halverson in a 1983 interview, one of the Gulleys' landlords had taken the following position: "I'm running for alderman and I can't get anywhere when I have a colored person living in my house." Gulley, discouraged and fed up, almost left Madison. To retain him, Halverson had a small apartment built for Bea and Carson in the basement of Tripp Commons.

Gulley's job in the early 1930s was to cook prodigious amounts for the five hundred men then living in the University of Wisconsin dorms, as reported in the *Capital Times* of November 30, 1931:

One meal at the refectory often demands the preparation and serving of 425 pounds of beef, four bushels of carrots, five bushels of potatoes and 45 gallons of milk. According to Miss Beulah Dahle, assistant director of dormitories and commons, the hungry band of 500 students requires daily from 80 to 100 loaves of bread, 60 to 70 pounds of butter, and 120 gallons of milk. Nine dozen heads of lettuce are purchased daily.

Carson Gulley's fudge-bottom pie is a two-layer custard affair topped with whipped cream in a buttery graham cracker crust.

In 1936, Gulley was called on to come to the Tuskegee Institute, the prestigious historically black university. He spent ten weeks of that summer at Tuskegee, working with George Washington Carver to develop a commercial dietetics course. Working in this supportive environment, he was greatly inspired by Carver, who recognized Gulley's artistry and encouraged him to continue teaching and to write a cookbook.

During World War II, Gulley developed a training course at the University of Wisconsin for U.S. Navy cooks and bakers. And in 1949, he finally published that cookbook, *Seasoning Secrets: Herbs and Spices*; this was revised in 1956 and published as *Seasoning Secrets and Favorite Recipes of Carson Gulley*. The second cookbook included his most prized recipe for fudge-bottom pie, which is still served with pride at the university.

From 1953 on, he and Bea took their love of cooking and teaching to the airwaves. From 1953 to 1962, they hosted *What's Cookin'* on WMTV and were also the hosts of the *Cooking School of the Air* on WIBA 1310AM. Gulley was a beloved community figure and a popular speaker at women's club meetings and on the lecture circuit. His accolades were impressive and included an Award of Merit from the Wisconsin Restaurant Association in

1948 and an entry in *Who's Who in Colored America*; he was a member of the Madison chapter of the NAACP and the Prince Hall Masonic Lodge, and both he and Bea were active members of Mount Zion Baptist Church.

Gulley retired early from the university in 1954 after twenty-seven years working in kitchens but never as a supervisor or manager. Just prior to his retirement, there had been some staff changes in the university housing department. Barbara Robinson Shade's 1979 summary of Gulley's career stated that despite his expertise, popularity and warm-heartedness, Gulley had been frequently passed over for promotions in favor of less experienced white candidates. It was time for a change.

After retirement, Gulley was far from done working. He became a chef at the Maple Bluff Country Club and continued his media work and public appearances all over the state of Wisconsin. With retirement came the need to find housing beyond the apartment in the basement of Tripp Commons. On August 3, 1954, Gulley signed papers to buy an undeveloped lot in the city's Crestwood neighborhood, a new area a few miles west of the university and just north of Regent Street. Shortly thereafter, the board of the Crestwood Cooperative Housing Association received a petition signed by 31 of the association's 154 members asking the board to meet and discuss buying back the lot to prevent the Gulleys from moving into the neighborhood. The board met on September 16, 1954, and the proposal was defeated in a vote of sixty-four to thirty. Carson and Bea built their home, moved in and found that though some neighbors still carried chips on their shoulders, most (even some of those who had voted to keep them out) welcomed them. It hadn't been personal, they said, but instead merely the fear of their property losing value.

The Crestwood controversy made national news at the time not necessarily because the Gulleys' right to freedom of housing had been challenged but because it had been honored. In 1957, the episode became the subject of a case study of integrated housing and property values by the Wisconsin Governor's Commission on Human Rights, which concluded that property values in Crestwood did not differ from those in similar neighborhoods. The study concluded with the caveat that the Gulleys' case may have been unique because they were a middle-aged professional couple (as opposed to a younger family) and were also beloved local personalities—in other words, their acceptance as homeowners in a white neighborhood was just one step on the long journey to housing equality.

In December 1961, the Gulleys started the wheels in motion to build a restaurant and catering business, as well as a new residence at 5522 University Avenue. The restaurant opened on September 15, 1962, serving

weekend buffets. Tragically, just two weeks later, Carson was hospitalized, and he died on November 2, 1962.

Bea continued running the restaurant for a short while. By October 1964, ads for the restaurant stopped appearing in the paper, and in a 1968 feature on Bea, she said she was enjoying retirement, playing golf and having time to spend with her grandchildren.

Carson Gulley received many honors for his work in Madison. On February 20, 1966, the former Van Hise Commons in Elizabeth Waters Hall was rededicated as Carson Gulley Commons. Decades later, in 2012, there was a significant renovation of the commons to include a deli and carryout dining venue and community center space for the (now co-ed) UW dorms. The complex was also renamed the Carson Gulley Center.

CHICKEN SHACK (THE SHACK)

Madison proper's first restaurant owned by a black proprietor was Chicken Shack at 838 West Washington Avenue. Carrie Williams operated the Shack in the 1930s and '40s. She sold it to Curtis Lucas sometime before 1951, when Twilight Chicken Shack was the only Madison restaurant listed in the first edition of the *Negro Business Directory of the State of Wisconsin*.

In 1996, Carrie Williams's grandson Jerry Miller opened the North American Rotisserie restaurant at 2935 Fish Hatchery Road. The next generation of Miller's family, Mike and Kym, joined the business, which moved to 1614 Monroe Street in the early 2000s. Shortly thereafter, Forrest "Kipp" Thomas bought the store, which was popular, particularly with students, but was unable to weather a recession and closed in 2009.

TUXEDO CAFE

Zachary Trotter was one of Madison's first black nightclub and tavern owners. He moved to Madison from Georgia via Chicago in 1913, and worked at the Belmont Hotel before opening Trotter's Billiards on East Main Street. In 1928, he opened Tuxedo Cafe at 763 West Washington Avenue. He met his future wife, Maxine, in Madison, and they were married in 1944. The Tuxedo was a popular neighborhood spot under their ownership.

The Trotters lived nearby and also owned several rental properties in the neighborhood. So when the Triangle Redevelopment Project rolled through in the early 1960s, they were among the last holdouts, along with Licari's Tavern at 767 West Washington.

According to Richard Harris's 2012 book, *Growing Up Black in South Madison*, the Madison Redevelopment Authority took the Trotters' property for a price of $23,500, but these funds weren't made immediately available to the Trotters. Meanwhile, they were charged $200 per month for rent on that very property, a bill that was difficult to pay given that their business was closed and their own tenants had been forced to move. The Trotters worked with a realtor who had trouble finding a new location for Tuxedo Cafe; frequently an asking price would double after the seller learned they were the buyers. When the Trotters attempted to buy the building at 1044 South Park Street, a petition signed by over two hundred residents of the Bay Creek neighborhood prevented them from locating there. When pressed by a reporter for their reaction, the Trotters responded with grace, saying simply that they were disappointed with what had happened but were proud of the trouble-free reputation of their business.

Continuing their search, they settled on a small building a few blocks farther south at 1616 Beld Street. Despite the fact that a group of fourteenth ward residents hired a lawyer to fight the transfer of their liquor license,

The two-story brick building at 1616 Beld Street, home to several African American–owned businesses, has an important place in Madison history.

MADISON FOOD

on June 20, 1961, the Madison City Council approved their move. Licari's Tavern also had trouble finding a new location, eventually settling on 1405 Emil Street. Both businesses reopened in early 1962, and Licari's is still in operation today.

Zach Trotter died in 1966. The late 1960s were not a trouble-free time for the Tuxedo or its successors. The business changed hands and was briefly operated as Johnny's Lounge by jazz musician John Shacklett. It later became Mr. P's Place, owned by Roger Parks and his son, Eugene, a prominent Madison political figure and civil rights leader. After Eugene Parks died in 2005, Baptist pastor and entrepreneur Larry Jackson bought the property. In November 2006, Jackie and Linda Clash opened Jada's Soul Food there. Jada's was open until 2007, and for a little while in 2008, David's Jamaican gave it a go. In 2010, Jackson, who had run Delta Taste restaurant at 2465 Perry Street in the late 1990s, took over the food service himself, naming it JA's Soul Food, but this, too, was not open long. In 2014, Naty's Fast Food was in operation, and signs for Mr. P's and JA's remained as hints of the past.

PURLIE'S

Other soul food restaurants found it hard to gain a foothold in Madison. Business directories produced by the *Madison Times* and *Umoja Magazine*, as well as the occasional obituary or news item, mentioned such venues as Raymond Parker's Original Barbeque House at 903 Williamson Street (circa 1972), Terry Stigler's restaurant and Pic-Nic-A-La-Tour catering company (1990), Yvonne Crawford-Gray's Holle Mackerl at 111 River Place and Regina Rhyne's Regine's Restaurant at 2705 West Beltline Highway (1998–2001), Doug's Soul Food Cafe at 1325 Greenway Cross (2008) and Carmell Jackson's Melly Mell's at 313 West Beltline (2012–14). Food carts with soul food–esque menus like Jin's Chicken and Fish, Raffy's and JD's (which also has a popular late-night storefront at 317 North Bassett Street) have also popped up. While the previous list is by no means complete, it gives a feel for how fluid the soul food scene can be in Madison. One exception to the revolving door was Purlie's, which was open for nearly twenty years and was a hub of community life in the 1980s and 1990s.

Purlie's opened in September 1981 at 2102 South Park Street, replacing Mr. Bill's, another soul food establishment, in a building that once housed a Kentucky Fried Chicken. Dewitt Moore and Peggy Howard

80

ran the place. Moore had attended high school in Milwaukee but was originally from Aberdeen, Mississippi. Howard was from New York City and had learned North Carolina–style cooking from her father. Despite the difficulty of finding the right ingredients for her family recipes, she was talented enough to work with what was available, and a fandom followed—particularly for the ribs, which were voted among Madison's favorites in *Isthmus*'s first reader polls.

More than that, Purlie's was a gathering place. Politicians, most notably Eugene Parks, pressed the flesh and passed the hat there. Purlie's also made it through a rough patch when a deputy city attorney made a case to close the venue because of a rash of police calls to the area. Moore's leadership kept the doors open and helped quell the calls. Moore passed away on May 29, 1998, and Purlie's closed in 2000. It was replaced by Mercado Marimar, a grocery store that was part of the wave of Hispanic-owned businesses entering the Park Street corridor at the turn of the twenty-first century.

6
AN ISTHMUS OF MEAT

BURGERS IN MADISON

W isconsin is perfectly situated to make the best burgers in the country. The state has some of the finest meat, the very best cheese and, most importantly, a culture that supports bar-and-grill taverns in even the smallest of hamlets. Add Madison eaters' enthusiasm and willingness to eat a burger in nearly any context—from shiny Graze to grimy Bennett's—and you get a lot of good burgers.

Ralph L. Richardson has been credited with bringing the first hamburger to Madison. He opened his lunch wagon, the Columbian, at 2 East Main Street on June 21, 1902. At the time, hot dogs were the standing order. Madison had about eighty saloons and just eleven restaurants around this time. Most beer halls offered a free lunch (usually salty), which attracted students, and wagons like Richardson's were encouraged as a "healthy" alternative. He eventually ran five such spots at 415 State Street, 605 East Wilson Street, 627 West Washington Avenue, 230 King Street and 820 University Avenue.

Richardson died in 1918. His widow, Mae F. Peltier Richardson, kept a financial interest in the wagons until her death in 1947, and longtime employee Lawrence "Larry" Tuttle took over daily operations. The wagons became even more popular after Prohibition put the beer halls out of business, and the Columbian was open around the clock. Mae's brother, Albert M. Peltier, had a wagon on King Street that was favored by Robert LaFollette and other legislators. State Street's wagons continued to be beloved by students, though their wholesome image grew tarnished by the

mid-1920s. As a *Capital Times* editorial complained on January 7, 1926: "The appearance of a new dog wagon on State Street is only one more example of the manner in which we permit the scarring and mutilation of Madison for personal profit."

HENRY STREET
RED & WHITE AND THE PLAZA

Just off State Street, an alternative to outdoor scarfing of hot dogs opened on November 24, 1926. Red & White Hamburger System at 309 Henry Street was to be one of the longest-lived hamburger joints in Madison, operating in a tiny eight-seat storefront until 1985.

A few doors down, the Plaza Building had gone up in 1918 at numbers 315 to 319. Over the years, it housed a number of businesses, including a Ward-Brodt music store, a barbershop and a bowling alley. The pool hall at 319 made the papers for being UW football star "Moon" Molinaro's spaghetti and gin joint, which was raided in 1933.

The Plaza, open since 1929, was first advertised as both a tavern and grill when John Sutter was the owner in 1935.

In 1939, Al Grebe bought the Plaza. In 1940, Olney A. "Paul" Quale took over the Red & White from its founder, F.J. Feldman. By the 1940s, popular tastes had shifted away from the hot dog in favor of the hamburger, and the Red & White was the place to go; speedy service, nickel burgers on fresh buns from Gardner Bakery and pies from Elsie Klein's Bake Shop sealed the deal. Robert "Red" Faltersack started working at the Red & White in 1950 and replaced Quale as owner at the end of 1965. For years, Faltersack was the unofficial "mayor of Henry Street," and his customers included everyone from his neighbors in the Plaza Building to politicians, journalists and Central High School students. Loitering in the tiny storefront was discouraged, and if Faltersack caught a customer reading, he'd shoo them out *tout de suite*.

Meanwhile, the Plaza was still known more for its schooners of beer than for its burgers. This began to change in 1945, when Mary and Harold Huss joined the staff. They took over management of the Plaza from Grebe in 1951, eventually buying the building from him in 1963. Their family's dynasty lasted another forty years. Mary and Harold's four children—Jim, twins Tom and Peg and Kathy—all grew up working at the Plaza. About 1965, Mary Huss made one of the most famous contributions to Madison cuisine: her Plaza sauce. A carefully guarded secret, the creamy, zingy sauce is served most often on the Plaza's dainty burgers but is also great on a chicken sandwich or as a sauce for dipping curds or fries.

Plaza and Red & White happily coexisted on the changing block until Faltersack retired in 1985, marking the beginning of three decades of shorter-lived tenants for 309 Henry Street. It held a florist for a couple years and then, in September 1989, became home to Michael Matty's first Madison Bagel Co. In 1998, Li Zhang opened ChinMi there, a homey Japanese restaurant that drew the eyes of passersby with its colorful *sampuru*, plastic displays of sushi and soup. In an unusual move, ChinMi decamped in 2004 and took over a truck stop restaurant in Verona. Zhang kept the Henry Street lease to open Burger Joint, a creative but short-lived venture. It was followed in 2007 by Mad Dog's, a Chicago-style hot dog restaurant (not to be confused with Eddie Ben Elson's Mad Dog carts) run by Brad Bailey and Paul Frautschi until July 2009. Nate Schiesser and Steve Nelson, former food director at Bethel Lutheran Church, ran Mad Dog's until the end of 2012, when it was replaced by chef Nick Baertschy's Southern California–style Get Some Burritos.

Meanwhile, the Plaza trudged along steadily. On March 1, 2003, there was a changing of the guard. The Huss family retired and sold the business

to longtime employee Dean Hetue, who was the first non-Huss to learn the secret Plaza sauce recipe (but not until all the papers were signed and money had changed hands). In recent years, the Plaza has undergone a subtle transformation into an "eco-dive." Bartender and Edgewood College student Katya Szabados assessed the environmental impact of everything from lighting to dishes for a capstone project for a Sustainability Leadership program and yet managed to leave the spirit of the place intact. A Plazaburger on a melamine plate remains a quintessential Madison meal.

DOTTY DUMPLING'S DOWRY

D. Jeffrey Stanley was on a personal mission to restore the quality of American hamburgers when he opened his burger stand in 1975 (or 1974). A history major and the son of a Beloit College basketball coach, he was the owner of a head shop in Des Moines, Iowa, called Dotty Dumpling's Dowry. A friend had coined the name in 1969 based on a faintly recalled literary character, ostensibly from a Sir Arthur Conan Doyle story but more likely from the British pantomime play *Old King Cole*. Stanley got the message to go into the burger business while meditating on a lake in northern Wisconsin. He bought the Quonset hut at 1720 Monroe Street that had been Emmett's Shoe Repair since about 1941 and soon won a loyal following with his fine burgers and hospitality.

In 1977, Dotty Dumpling's Dowry was forced out of its location, along with several other small Monroe Street businesses, by the expansion of Randall State Bank. Dotty's was the last to move out, finding new digs at 1441 Regent Street. Its fans followed it to the forty-eight-seat restaurant that was called, by John Bordsen in the *Capital Times* of April 20, 1978, "the most visually gratifying burger shop in Madison" because of its walls covered in antiques. The burgers were often named the best in Madison, especially when served with cheddar cheese sauce. In 1980, Joe Harrison's chili won the Wisconsin State Chili Cookoff in Green Lake. "Granny's mild chili" was also available for the less adventurous.

By 1982, Stanley was calling himself the Hamburger King of Madison, a title longtimers like Red Faltersack challenged. But Dotty's was at the top of its game. In 1989, a mention in *USA Today* boosted Dotty's business by 40 percent. Despite Stanley's preference for operating on a small scale, demand suggested it was time for another move. So in the 1990s, Stanley

Dotty Dumpling's Dowry, "World Hamburger Headquarters."

started shopping around for more space. Down the street, the Percys talked to Stanley about taking over Mickies Dairy Bar, but ultimately they sold to Payow Thongnuam. Encouraged by the success of Blue Marlin and other classy developments downtown, Stanley bought the former Pirate Ship Bar on Fairchild Street and opened there in 1991.

It was the beginning of a great decade for Dotty's. Customers were attracted to the rapidly revitalizing State Street area. And it helped that in 1992 Cindy "the Pie Queen" Edwards came on board. Formerly a clinical researcher at UW Hospital, Edwards said she'd found her calling making fudge-bottom pies and other favorites for Dotty's. Their burgers and chili still won fans by the hundreds.

Success sometimes leads to dramatic changes. This played out in 1999, when Stanley became engaged in a two-year battle against Overture Foundation and the City of Madison. Dotty's was on a block slated for redevelopment into the major arts complex, and legal struggles ensued. Once again, Dotty's dug in its heels but ultimately was forced to close. July 19, 2001, was demolition day, and Stanley, discouraged, retreated.

Slightly more upscale and a little less cluttered at its fourth location, Dotty's still serves killer burgers and good chili. *John Benson CC BY 2.0.*

It was not long, however, before the dream of burger greatness called Dotty's back into business. The former Black Bear Lounge at 317 North Frances Street—just down the block from another burger institution, the Nitty Gritty—became Dotty's new home in 2003.

THE NITTY GRITTY

The Nitty Gritty is Madison's "official birthday bar." Its original 1968 location at 223 North Frances Street was joined in 2002 by one in Middleton (1021 North Gammon Road) and in 2013 another in Sun Prairie (315 East Linnerud Drive).

In the late 1960s, local television personality and sports journalist Marsh Shapiro and his wife at the time, Gail, bought the 1898 building that had housed Glenn-N-Ann's Cozy Inn since 1944 and prior to that had been a general store. Shapiro opened the Nitty Gritty on October 3, 1968. It attracted countercultural movers and shakers and anti–Vietnam War activists, even gaining the dubious distinction of being the site where the 1970

Sterling Hall bombing was planned. The Nitty Gritty was also a regionally known blues music venue until the mid-'70s. The year 1975 brought the end of the live music era, and 1985 was the dawn of the Nitty Gritty as Madison's Official Birthday Place, where guests are celebrated with a peal, a song and free stuff. According to the restaurant's website, the downtown Nitty averages 57 birthday celebrations per day with a grand total of over 600,000 by 2014.

In 2010, Shapiro and his then wife, Susan, retired, selling the downtown and Middleton locations to Eric and Caitlin Suemnicht; Lee Pier; and his wife, Ragen Shapiro. Three years later, the Sun Prairie Nitty Gritty opened in the historic Sun Prairie Canning Company building that had been home to the Cannery Bar and Grill from 2007 to 2013. From 1900 to 2000, the spacious brick structure had operated as a cannery and, in 2004, was added to the National Register of Historic Places.

All three locations serve the Grittyburger. It's a frequent winner of local best burger awards and comprises a six-ounce patty of ground chuck on a dark honey wheat bun with a tangy, orange-tinted secret sour cream sauce. The Nitty Gritty's extensive menu also includes dozens of sandwiches, sides like curds and fries and its signature "World's Smallest Chocolate Sundae" for a dollar.

NIBBLE NOOK

Before McDonald's came to Madison in 1957, there was the Nibble Nook. Jim Larrabee of Marshall and Art Zurbuchen of New Glarus partnered up in Waterloo, Wisconsin, to open their first Nibble Nook in 1955. At its peak, the burger parlor had five independently owned locations in Madison: 1244 East Washington Avenue, 1 South Park Street, 206 East Washington Avenue, 2013 Atwood Avenue and 1401 University Avenue. The Park Street Nibble Nook had one of the shorter runs, ending on November 30, 1962, when the Madison Redevelopment Authority bought the property for $13,200 as part of the Triangle Redevelopment Project. Conversely, Atwood Avenue's Nibble Nook lasted two decades under the management of Al and Shirley Roehling, Stanley Crabtree and Patrick and Phyllis Collins.

Probably the most important Nibble Nook franchisers were Bill and Betty von Rutenberg. Bill worked at Neesvig's Madison Packing Co. before he and Betty went into business for themselves at the 206 East Washington Nook in 1961 (some sources say 1962), serving the small-pattied burgers on

Gardner's buns with Gordy's pies for dessert. In 1966, they sold the Nook to buy Mariner's Inn on the north side of Lake Mendota. That Nibble Nook closed in 1970, but Von Rutenberg Ventures has become a Madison legacy. Today, Bill and Betty's sons, Bill, Jack and Robert, continue to operate Mariner's Inn in supper club fashion, offer seafood and casual dining at Nau-Ti-Gal and Captain Bill's (formerly the Hatch Cover) and host dinner and special event cruises on the *Betty Lou* in summer.

MONONA DRIVE-IN (HUNGRY, HUNGRY, HUNGRY)

The story of the Monona Drive-In is a "farm-to-table" tale of a different type. Catherine Murray recounted it in detail in the *Wisconsin State Journal* in October 1994, just after the fifty-five-year business served its last root beer. In her article, she wrote of John and Margaret Walterscheit, German immigrants to Blooming Grove in 1885 whose farm spanned three generations. In 1938, Guy Ward and his wife, Ruth Davis, Walterscheit's granddaughter, were struggling to make ends meet on the farm. They bought a barrel for making root beer and opened the Monona Drive-In in the spring of 1939. Other Madison-area drive-ins included, over the years, the Polar Bear at 2801 Atwood Avenue, the Stein (also on Monona Drive) and even an add-on to the Cuba Club on University Avenue.

In 1949, the original building—a tiny square hut that Ruth and her father, George, built—was replaced by a hexagonal structure with an orange roof and three rows of parking for carhops to serve. A new sign reading "Hungry, Hungry, Hungry" went up, and soon, it caught on as a nickname, sometimes shortened to just "Hungry, Hungry." The same year, the Wards started serving the first curly fries in Madison. They used a table-mounted auger and peeler to get the curly shape and a two-day soaking and double-frying method to achieve potato perfection. Eight years before the first Golden Arches appeared in Madison, the Hungry, Hungry was stocking up on the best fresh potatoes in order to satisfy the one-thousand-pounds-per-day demand. Two and a half decades of drive-in memories were made at the Hungry, Hungry, but by 1976, the heyday of the drive-in was past. Jon Ward, Guy's son, cut the carhops, remodeled and renamed the Hungry, Hungry "Big Jon's." Despite an expanded menu, it never quite captured the same audience as the original. In 1994, Ward sold the land to an apartment developer, bringing over a century of farm and table service to an end.

TONY FRANK'S

The land at 1612 Seminole Highway where the original Tony Frank's tavern now stands used to be a fox farm. Tony Frank's has been a family-run business since it opened in 1929, and *Wisconsin State Journal* columnist Doug Moe contends that it is the longest continuously running bar or restaurant in Madison. At one point, there were four Tony Frank's: the original Seminole Highway location; 3302 Packers Avenue; 2952 Fish Hatchery Road; and one outside Madison, in the city of Spring Green.

In its early years, Tony Frank's dodged the law, first for operating as a speakeasy and later for running illegal slot machines. Tragedy marked its middle age. In 1962, Anton E. (the original Tony, owner-operator since 1932) died of a heart attack while on a trip to Arkansas. His grandson John was struck and killed by a car while crossing the old Beltline on foot, heading home after a night's work in the kitchen in March 1969. John's father, Edwin, also died of a heart attack suffered while working at the Packers Avenue bar in October 1971.

Evelyn V. Frank, Edwin's wife, then assumed management of the taverns. For over two decades, Evelyn—as well as her daughter, Karen Dowling, and sons, Jim and Jeff—was known for her commitment to keeping the family business. Their dedication was rewarded. The Fish Hatchery location opened in 1973, and by 1989, a food critic had declared

Today, the cheerfully shabby Tony Frank's overlooks the Beltline highway from the edge of a tree-lined residential street.

The cheeseburgers at Tony Frank's are among the best in town.

that Tony Frank's food was so good that it had officially crossed the line from bars that serve food to restaurants that have bars.

Evelyn passed away in 1996. In 1997, the Packers Avenue Tony Frank's briefly became Jimmy Frank's, but the location grew unable to sustain restaurants. The short-lived Runway, El Corral and La Finca tried and failed after Jimmy Frank's closed. Around 2002, the Fish Hatchery location started to be called Schneid's Tony Frank's, gradually transitioning to just Schneid's, and expanded its menu to include a wide range of classic sandwiches, soups and an excellent fish fry. But the original Tony Frank's is still there on Seminole Highway, and it is still a great place to get an excellent burger.

TODAY'S WELL-DONE BURGERS

Nowhere in Madison is very far from a very good burger. Here are some more enduring favorites.

The building at 1201 Williamson Street was constructed in 1911 and served as a grocery store for most of the twentieth century.

At Village Green, 7508 Hubbard Avenue in Middleton, Ron Boyer and his son, Craig, run the grill and turn out a consistently tasty product. Ron got his start at another Madison food nostalgia spot, Kelly's Drive-In, in the 1960s. He bought Village Green from Harvey and Eileen Simon Tesch in 1976, who had phased out the business's original function. The building had housed Middleton's second bowling alley when it was first built in 1926. The bowling alley operated intermittently under several owners until 1971, when manual lanes went out of fashion but automating was more expensive than converting to a full-service restaurant.

The Weary Traveler Freehouse distills the Madison food scene into one experience at a good value. Chris Berge opened the English-style pub in 2000 in the former home of Coyote Capers, the eclectic-to-erratic venture of Berge's fellow Ovens of Brittany alum Ana Larramendi. Today, the Weary serves upscale tavern food with an international flair but is best known for its iconic Bob's Bad Breath Burger, which is loaded with onions, garlic and cream cheese.

Antlers, 2202 West Broadway Avenue, was built in the 1930s as a rough-and-tumble tavern for construction workers. Today, it's owned by—don't laugh—Homer Simpson II. His father, Homer V. Simpson, won half the bar in a poker game and bought the other half in 1943. Before he died in 1963, Simpson's generosity in donating land to the city earned him a street name. His wife and son moved into the back of the tavern, and when Homer was old enough to take over the family business, he continued his father's

tradition of good food and fellowship. The Bridge-Lakepoint neighborhood fell on rough times, however, and as part of the city's revitalization efforts in the early '90s, Simpson Street became Lake Point Drive. In 2014, Homer V. Simpson's memory was again honored with a street sign at the corner of Lake Point and Hoboken Drive in the tightly knit neighborhood. All this is background to Antlers' simple and unassuming but delicious bar burger served on a Kaiser roll.

Similarly, Brothers Three at 614 North Fair Oaks Avenue serves up honest greasy spoon fare. Gus, Bill and Pete, sons of American Lunch proprietor Theodore Fotes, ran the restaurant in a refurbished filling station for its first few decades. The Fotes family also owned the Pinckney Street Hide-a-Way, one of the last and most beloved working-class bars in downtown Madison. In 1986, Rick Sawyer took over and continued the brothers' delicious legacy. The mushroom burger is one of the best of its kind in the city.

7
MADISON'S CULINARY GODMOTHER

THE OVENS OF BRITTANY STORY

O vens of Brittany opened in the summer of 1972, bringing life and fire to the Madison food scene. Its French-style cooking and bakery was served with equal parts earnestness and joy. While Simon House and Madison's other classic fine-dining restaurants served Continental fare to the well-heeled, Ovens' approach appealed more to the young, idealistic and hungry. It survived early struggles and went on to great success. At its peak in the early 1990s, there were four restaurants, two cafeterias and catering and concessions businesses in Madison and beyond. Over the course of a twenty-eight-year run, Ovens employed thousands (estimates range from ten to twenty thousand), and many of the most influential Madison restaurant operators are Ovens alumni. In particular, 1994 sparked a handful of creative individuals into ventures of their own, just as Ovens itself began to flounder. Later surveys of the dining scene included Ovens of Brittany with the Fess and L'Etoile as part of a wave of excellent restaurants that opened in early 1970s, but this was only part of its story.

It began with Jo Anna Utley Guthrie. Born in the early 1920s to two employees of the B.F. Goodrich Rubber Company outside Akron, Ohio, Guthrie led an extraordinary life. While working as a secretary at Goodrich, she married Diego Ybarra and had a son, Robert Ibarra (an Anglicized spelling). The family moved to Venezuela, where Guthrie became involved with Winthrop Rockefeller, who invited her to New York City; she left Diego and brought Robert to Akron to live with her parents en route to New York. There, she studied interior design while becoming close with the Rockefeller

family. After a brief hospitalization for mental illness, Guthrie started over in Ohio, where she worked at television stations in Cleveland and Akron, married again and had another son. She began to delve deeply into esoteric philosophies. She eventually moved to Wheaton, Illinois, where the Theosophical Society in America was based. She was married to Dr. Henry A. Smith (a prominent member of the society and its one-time president) from 1964 to 1971. In 1967, Guthrie founded the Phoenix Academy of Cultural Exploration and Design based on Theosophical Society ideals.

The Phoenix Academy met in Guthrie's home to discuss holistic spirituality, philosophy, religion and psychology. In 1968, Guthrie bought farmland near Gays Mills in Crawford County, Wisconsin, to establish "Fellowship Farms." Here a Phoenix member named Bob Gore managed the farm, and it became a successful operation, with a bed-and-breakfast chalet, a dairy herd and productive cropland.

Guthrie then sought to buy an empty monastery in southern Wisconsin for the society to use, but when this deal fell through, she left Illinois to move to a house on Kendall Street on the near west side of Madison. The rambling Victorian building was large enough that several members of Phoenix were able to follow her there. With the produce of a working farm and plenty of helpers at its disposal, the fellowship decided to try its hand at restaurant hospitality and health food sales.

OPENING OF STATE STREET OVENS AND CRITICAL ACCLAIM

The site they chose was 305 State Street, which had housed a wig shop and needed significant work before it could be used as a restaurant and grocery. The small but dedicated crew spent weeks in the spring of 1972 preparing the building for what would become Concordance Natural Foods, with Ovens of Brittany in the basement. The restaurant's official opening was on July 1, 1972, and its first meals were cooked in a kitchen equipped with only an electric hotplate and two ovens because proper ventilation had yet to be installed.

Word of mouth and a plywood sign were all Ovens needed to become an instant success. Its nine tables were in constant demand, and the staff of eight, none of whom had had any significant restaurant experience, learned as they went. Richard Borovsky; David Yankovich; and his wife, Karen

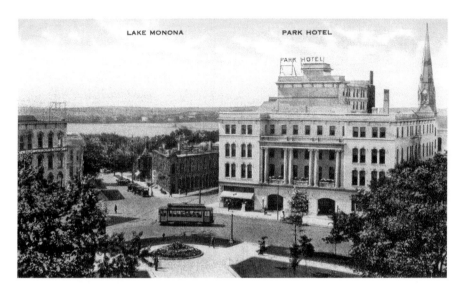

The Park Hotel, built in 1871 to boost Madison's statewide profile, got a new façade in 1911 and was demolished in 1961 to make room for the Inn on the Park. *Wisconsin Historical Society, WHS-44063.*

"Sunshine Through the Tulips": bright flowers greet people on Capitol Square. *Stephen J. Kessenich.*

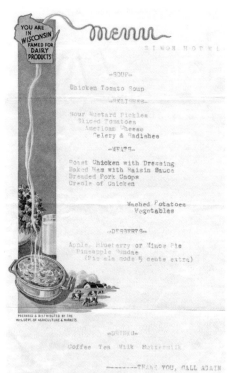

Left: An undated, mimeographed Simon Hotel menu on a form from the Wisconsin State Department of Agriculture and Markets. *Wisconsin Historical Society, WHS-106420.*

Below: Red & White Hamburger System was at 309 Henry Street for six decades and hasn't yet faded from Madison's memory.

A scrambler at Mickies: "yanks," eggs, and cheese with gravy and a side of toast.

Above: Open since 2009, Fugu is the latest occupant of 411 West Gilman Street, which once housed Brown's Restaurant and the original Rocky Rococo's.

"Saturday Morning Hustle and Bustle": the lively May crowd at the Dane County Farmers' Market shops near L'Etoile. *Stephen J. Kessenich.*

"Veggies": a full spectrum of fresh produce awaits Dane County Farmers' Market shoppers each August. *Stephen J. Kessenich.*

Right: Snug Haven Farm's red ripe tomatoes are "Grown in Real Dirt" in a cozy dale just south of Madison. *Judy Hageman.*

Below: Snug Haven Farm's spinach grows in hoop houses throughout the cold months, giving it a hearty frost-sweetened character.

Herds graze in fields along the Military Ridge State Trail, a recreational path connecting Madison with Verona, Mount Horeb, Blue Mounds and points west.

This giant wheel of Meister's Morel and Leek Jack was one of the locally made wonders at an annual Isthmus Beer and Cheese Fest.

Dairy cows are a common sight around Madison and Dane County. *Courtesy of the Wisconsin Milk Marketing Board, Inc.*

"Ready for Harvest": late September fields of grain wait in the late afternoon on a farm near Monroe in Green County. *Stephen J. Kessenich.*

Village Green in Middleton was once a bowling alley and today serves up some pretty good burgers.

The basic burgers at Village Bar, one of the Westmorland neighborhood's longest-established businesses.

Right: Tony Frank's opened at 1612 Seminole Highway in 1929.

Below: Elaborately garnished Bloody Marys are not out of place at tailgates on Badger football Saturdays.

Below: Morning buns, Ovens of Brittany's signature bakery item, can still be found all over Madison. Lazy Jane's serves one of the best versions.

Mickey's Tavern, a popular bar for Sunday brunch, in 2013. *Richard Hurd CC BY 2.0.*

Right: Mary White's Bea's Bonnet was open from 2011 to 2012 at 2302 Atwood Avenue. The tiny storefront became the Chocolate Shoppe in 2014.

Below: The unique building at 802 Atlas Avenue has housed many restaurants, including a Wisconsin Dells chain that painted the exterior hot pink.

Inside Ella's are hundreds of motorized contraptions, handcrafted in Madison by Ken Vogel, Jerry Siegmann and Al Bayer. *Joseph Kranak CC BY 2.0.*

Ella's carousel horses originally came from Cincinnati and were lovingly restored on site.

Opposite, bottom: The ahi tuna poke at Umami, 923 Williamson Street, with apple cucumber slaw, seaweed salad and crispy pork skin.

A to-go container of soul food from JA's, once on Beld Street: chicken, fries, mac and cheese and white bread.

Local cheeses adorn a platter at Sow's Ear, a yarn store and coffee shop in Verona, just southwest of Madison.

Vientiane Palace at 151 West Gorham Street serves Lao-Thai favorites, including "Paradise Meat": beef strips in a tangy glaze.

Rising Sons Deli is not technically a deli, but it is a good place for Thai food. The restaurant's "Alley Cat" patio is the smallest in town.

The spicy Dragon Pizza at the erstwhile Page Street Pizza in Stoughton, since replaced by Famous Yeti's, featured hearty crust and lots of cheese and nontraditional toppings.

Taqueria Guadalajara opened in 2006 at 1033 South Park Street, the former home of American Lunch.

Stella's Bakery sells its famous spicy cheese bread and other Madison traditions at the Saturday Dane County Farmers' Market. *Kristine M. Stueve.*

McKean, were among the originals. Karen invited her brother Mark to a job "garnishing plates," and John McKean, their father, invested money in the operation. During this early phase of the Ovens of Brittany, Guthrie gave weekly inspirational talks to the staff, and Karen McKean attributed their early success to the spiritual energy behind the restaurant.

Nine months after Ovens opened, *Milwaukee Journal* food critic Herbert Kubly gushed: "The word from Wisconsin's second city was cause for celebration. In a dining desert where I had been unable to find a single restaurant of distinction, a new establishment called 'Ovens of Brittany' was described by the *National Observer* as 'one of the nation's most unusual' restaurants." Kubly himself had to try three times to make a reservation. He described the food as delicious and mostly consistent. He quoted staffer Suzanne Lind as saying, humbly: "We have become successful so quickly because there is nothing in Madison with which to compare us. I feel we have much room for improvement."

To today's eaters, it may sound like an exaggeration to claim that Ovens of Brittany was the Promethean force that ignited Madison's restaurant scene. But in context, Ovens' French pastries and thoughtful vegetarian entrées, were truly something new that arrived at just the right time. In 1974's *Getting the Most Out of Madison* guidebook, Janice Durand wrote:

> [Critic] *Craig Claiborne will never break a leg hurrying to Madison to review a restaurant. An unnecessarily harsh judgment, some may say, but I include it for a reason. Nothing is more detrimental to the pleasures of eating out than unrealistically high expectations. If you understand from the outset that Madison has no great restaurants, you will enjoy eating at the many good ones it does have.*

She went on to recommend Ovens of Brittany highly in a short list of worthwhile Madison eateries that included Andrea's (run by Andrea Craig, an Ovens alumna, at the address soon to be occupied by L'Etoile), some State Street favorites (Athens, Brathaus, Ella's Deli, the Grotto, Parthenon and the Plaza), fine dining (the Edgewater and Mariner's Inn), Italian (Gargano's, Gino's, Lombardino's, Paisan's, Peppino's and Porta Bella) and supper clubs (Minnick's Top Hat, New Pines, Rohde's and Smoky's Club).

Ovens of Brittany's reputation also gained it a spot in *Wisconsin Quantity Cuisine*, Charles Church's 1976 survey of institutional food in Wisconsin. Church credited Ovens of Brittany with starting a "restaurant revival that lifted the capital city out of the cellar and into the number two spot within three

years." Ovens of Brittany was listed with Andrea's, the Edgewater and Chalet St. Moritz in Middleton as industry leaders.

By October 1973, Ovens had expanded into the travel agency next door and opened the Bakers' Rooms, which had a window through which passersby could watch the bakers at work. It was also where Karen Piper (who chose her name Odessa as a feminine form of Odysseus) is credited with making the first croissants in Madison. These led to two Madison originals: the morning bun and the Karen bun. The morning bun is made with croissant dough rolled with ample cinnamon sugar. Officially called a Brittany Bun by the Ovens, it is ubiquitous in Madison today and once was served as a snack on Midwest Express airlines, such was its popularity. The Karen bun also used croissant dough topped with an orange glaze.

Ovens of Brittany was poised for groundbreaking success, but first, there was a firestorm to survive.

FORECLOSURE AND DISSENT

By 1974, the staff of Ovens and the Bakers' Rooms had grown to about eighty, a third of which were members of Phoenix. Dissatisfaction at the perception of discrimination against non-Phoenix employees had begun; at the same time, financial trouble was brewing. A labor union called the Independent Ovens Union was established with a 53–0 vote on December 9, 1974, and two days later, the staff went on strike. At the same time, the financial backers of the Ovens were facing foreclosure on the building. Guthrie's unifying force had turned divisive when she expelled seventeen people, including key manager David Yankovich, from Phoenix, though he assured customers that this had no impact on the operation of the restaurant. After Guthrie failed to appear in court to address the foreclosure action, it was discovered that she had been misappropriating restaurant funds. Her erratic behavior proved to be a result of mental illness, which culminated in a week of involuntary institutionalization and then her disappearance from Madison. Reflecting on the events of late 1974, Phoenix members said that Guthrie's sickness had progressed but that they had been too busy with the restaurant—and too close to her—to see it; her "genius and illness were mixed together."

A HISTORY OF CAPITAL CUISINE

REORGANIZATION, REBIRTH AND THREE NEW OVENS

January 1975 saw Ovens reopening under the leadership of Yankovich and Borovsky. Mark McKean, who had earned an accounting degree at UW–Madison, became more involved in management in order to help the restaurant recover from Chapter 11 bankruptcy and to protect his father's investment. In an employee handbook from the late 1980s, a history of the Ovens states that at this point, the business was bought by its employees and run by Mark, Karen and John McKean.

Under this new arrangement, Ovens enjoyed continued popularity. Julie Burmeister, the head pastry chef, supervised a staff of ten bakers whose daily output included hundreds of Brittany buns, dozens of loaves of French bread and various decadent desserts, including the beloved Queen of Sheba chocolate torte.

In 1976, Odessa Piper and Jim Casey branched out to open L'Etoile, the first of Ovens' sparks to really catch fire. The same year, Bob Gore, key to the Fellowship Farms operation, returned from a stint in Minneapolis. He joined David Yankovich, Mark and Karen McKean and Diana Grove to opened a second Ovens of Brittany location at 1831 Monroe Street in autumn of 1978. The restaurant was small and intimate like the State Street Ovens, and its first reviewer also needed three tries before landing a table.

Three years later, in 1981, the Ovens' pattern of expansion continued but in a different direction. The construction of the Ovens of Brittany in Shorewood Hills, at 3244 University Avenue, was a major project; Taliesin-trained architect Herb DeLevie designed an elaborate multilevel restaurant with ample natural light and greenery, as well as a water feature. This was in sharp contrast to the warm, intimate setting the Ovens on State Street and Monroe had cultivated, with its green-striped wallpaper and refined touches. The new building housed a Concordance Natural Foods store as well.

The new Ovens' lighter menu reflected the trend of the time toward fresher, low-fat eating. The new kitchen was designed with built-in woks, and stir-fry became a signature dish. While popular on its own merits, and especially appealing to loyal customers (many of whom now had young children in tow), the new Ovens was also subject to criticism for having departed too far from its roots.

Key people were departing as well. "One by one the original members of the Phoenix group left McKean in stewardship," as McKean described it to *Madison Magazine* in March 1996. By 1981, McKean had become the major stockholder, and Yankovich was president of the company, which

employed about 250 people. Though news stories about the opening of the new Ovens identified the core team as Yankovich, Bob Gore, Mark McKean and Jeanine Hanson, the employee handbook printed in 1985 listed only Jeanine Hanson and Mark and Karen McKean as partners in the Shorewood Hills Ovens.

Still, new contributors to Ovens continued to rise through the organization. By 1984, plans had been laid for a fourth outpost at 1718 Fordem Avenue in the Camelot Square strip mall. Jane Capito and architect Arlan Kay designed Ovens East, and Capito, Mark McKean and Jeanine Hanson brought on Ricardo Paoli, Carole LeClaire and Virginia Evangelist as partners. In 1976, Capito had left Berkeley, California, and a career in social work to try her hand at restaurants. Her first job was waiting tables at Middleton Station (later Louisianne's Etc.), but she soon joined the Ovens staff on State Street, starting as a dishwasher. Her colleagues included Monty Schiro, who was managing Monty's Blue Plate Diner within a few years, and Terese Allen, who had begun at the Ovens on Monroe in 1982. Ovens East opened in 1984 to wide acclaim. Early reviews compared it to a Paris salon of the 1880s, with food as good as the other Ovens locations (and a little bit cheaper).

With four semi-independent restaurant operations in full swing, the organization branched out into other modes of service in the mid- to late 1980s. In 1982, a franchise operation had briefly been set to open in Milwaukee, but the deal fell through. Ovens had more success in 1987 taking over cafeteria operations as Brittany Cafe in the First Wisconsin/ Firstar Bank building on the Capitol Square. Ovens started catering, as well as baking for other restaurants, including the new Otto's on Mineral Point Road. The State Street Ovens played with different concepts and tried separate "Fountain" and "Fireplace" rooms and, later, a seafood bar and grill theme. Manager Abdul Bensaid oversaw these changes and later went on to open Oceans Brasserie in 1998 and then Nadia's in 1999.

CONSOLIDATION AND FURTHER EXPANSION

As "chairman of the boards" of the various Ovens, Mark McKean was always on the lookout for operational efficiencies. Administration, advertising and marketing had gradually consolidated as each new Ovens opened. Separate incorporation had been smart for Ovens on Monroe to insulate it from the original restaurant's bankruptcy, but now it made more business sense to try

to turn Ovens into a real chain—especially one that looked independent. Pride about local food had already taken root in Madison, along with several national chains and the idea that Madison boasted more restaurants per capita than average.

So Ovens looked outward. It sent feelers to Minneapolis but landed two venues closer to home: the Hotel Rogers in Beaver Dam and the Chesterfield Inn in Mineral Point. Hotel Rogers' renovated 1905 building was on the National Register of Historic Places, and Ovens operated there from 1990 to 1992. The Chesterfield Inn charmed Mineral Point and its visitors from 1989 to 1994 with a menu that still satisfied the region's proclivity for Welsh pasties and Wisconsin's love of supper club fare.

Terese Allen from Ovens East trained the staff at both hotel operations, and in 1991, she also released *The Ovens of Brittany Cookbook*. She presented a short history of the Ovens and brief anecdotes alongside classic recipes for chicken potpie, vegetarian stroganoff and stir-fry. Signature bakery items like croissants and Brittany buns were acknowledged but not included out of deference for the restaurant and a realistic idea of what home chefs could attempt. From a local lore perspective, the book is invaluable. At the time, it received mixed reviews; in the bigger picture, most of the criticism was of the sort that hinted that Madison had begun to take the twenty-year-old Ovens for granted. Still, Ovens changed with the times, tinkering with carryout for busy families and taking over the cafeteria at the Wisconsin World Trade Center in Middleton as well as catering operations at Olbrich Gardens, a prime wedding venue run by the city.

By late 1991, over 450 people were employed at all the Ovens of Brittany locations. The economy was strong and labor was in demand, and that, combined with the passing of the 1990 Immigration Act, opened the door to a unique opportunity. James Novak, the Ovens' comptroller and former owner of the Red Shed bar, was intrigued by the Tibetan Resettlement Project. He presented Mark McKean with the idea of offering entry-level jobs with benefits to twelve Tibetan refugees, thereby allowing them to enter the United States; McKean's answer was a fast yes. They viewed it as a good fit with the Ovens' early mission to change the world with hospitality.

In March 1993, Ovens considered another social project proposed by an employee—a restaurant at 306 North Brooks Street to replace a café called Main Course. The building was home to Community Housing and Services as well as a number of residents of single-room apartments on its upper

Porchlight Products ingredients are sourced from local farms, and the self-supporting program provides jobs and vocational training.

floors. Community Housing was looking for a food service provider that would also appeal to the crowds of business school students at the newly constructed Grainger Hall next door. All the interested parties were Ovens alumni: Andrea Craig and Nancy Christy of the Wilson Street Grill; Jane Capito, now at her own place, Botticelli's; and Ovens itself, which had an employee who was interested in starting a vegetarian café there. Sadly, none of these worked out.

However, the kitchen at 306 North Brooks had a future with restaurants. In 2006, Christy and Craig consulted with nonprofit Porchlight Inc. to launch the Porchlight Products line of jams, pickles, sauces and baking mixes. Local restaurants and retailers were enthusiastic about Porchlight Products from the beginning. Daisy Cafe & Cupcakery serves multigrain pancakes and orzo salad from the Porchlight line. Coopers Tavern's Reuben sandwich is made with Porchlight sauerkraut. Great Dane and other local bars have used dilly beans and pickled mushrooms for Bloody Mary garnishes, Lakeside St. Coffee House puts curtido (a spicy relish) on its turkey sandwiches and Short Stack Eatery buys its apple butter by the quart. The packaged products are also carried by some restaurants and groceries and are sold direct to the consumer via Porchlight's website.

THE FIRE SUBSIDES

Wilson Street Grill and Botticelli's were only two of many places that spun off Ovens in the early 1990s. Jane Capito observed that Ovens had always attracted creative people. Whether spurred on by differences of opinion or simply a desire for growth, many of them opened their own new and exciting restaurants. Eventually, this led to the demise of Ovens East, which closed its doors in December 1993. The article announcing its closing named several of the movers and shakers in the new generation of Madison restaurateurs. Among them were Anna Alberici (in partnership with Jane Capito at Wild Iris and Greenbush Bar), Ana Larramendi (Coyote Capers), Chris Berge (Blue Marlin, Weary Traveler and Natt Spil) and Brian Boehm and Andrea Kinderman (Deb and Lola's).

While there were rumors of the Ovens on State Street closing, these were premature—the popular Bakers' Rooms had been reinstated after the seafood grill concept sank. Meanwhile, Ovens took over Riverview Terrace, the café at the Frank Lloyd Wright visitors' center in Spring Green. On Monroe Street, a new chef named Howard Bender revitalized the menu with a fresh and local approach, which was received enthusiastically. After the pain of losing Ovens East, there had begun a slow swing back toward more independence and less corporate control, but it was too late. The business was no longer sustainable, and 1995 saw the end of the Ovens on both Monroe Street and State Street.

Ovens on Monroe's last day was June 18, 1995. Madison Bagel Co. moved in briefly, followed by El Charro, Martha Avila's popular but ever-moving cart/restaurant enterprise. Finally, in 1998, Finn Berge and Matt Weygandt established their original Barriques as a wine shop, subsequently adding gourmet coffee and light fare and opening locations in Middleton and Fitchburg, plus three more in Madison.

When Ovens on Monroe closed, Howard Bender joined the culinary team at Bluephies, Monty Schiro's place. Schiro had opened this second new American diner just a few blocks down Monroe Street in 1994. This was also the beginning of Food Fight, Schiro's approach to shared restaurant operations. Where Ovens struggled to find a balance between creative people and corporate control, Food Fight succeeded in launching dozens of unique restaurant concepts in the following decades. Each has its own culinary team supported by centralized administration services, which also allows Food Fight to offer stability and attractive opportunities to employees. Some restaurant concepts last longer than others, and any Food Fight venue

After the original Ovens of Brittany closed, 305 State Street became Mad City Diner and then Tutto Pasta.

that has rested too long on its laurels has needed to adjust. The resilience of shared risk and the flexibility of independent management are lessons learned from the Ovens experience.

October 29, 1995, was the last day of the Ovens of Brittany on State Street. The flagship restaurant closed after its Sunday brunch service. The Ovens hosted a closing party and reunion that brought back many of the Ovens' customers and employees for one last goodbye. To many Madisonians, this felt like the end of an era.

The building at 305 State Street remained a restaurant. After the ill-fated Mad City Diner succumbed to arson, the building stood vacant for more than a year before Enzo Amodeo took over and opened Tutto Pasta there in 1998. Ovens still ran catering operations on the square and in Middleton. Its Shorewood Hills location was still frequented by loyal customers, many of whom were of the same generation of students that greeted Ovens on State Street, now with children (or even grandchildren) in tow. And yet in his December 28, 1996 end-of-year restaurant wrap-up for the *Capital Times*, Michael Muckian wrote that while the food was still good, "it may not be fashionable to like the Ovens of Brittany."

And so in late 2000, the landlord of the Shorewood Hills location announced that Ovens of Brittany's lease would end on Christmas Eve. Assistant manager Elizabeth Garcia-Hall and her husband, head pastry chef Jose Garcia, had been in negotiations to buy the building, but ultimately, DeLevie's grand structure was subdivided and repurposed as retail space. The Garcias bought the Ovens of Brittany name and recipes from Mark McKean in hopes of rekindling the restaurant at a second-story space at 1925 Monroe Street, but the fire was gone.

WHERE ARE THEY NOW?

After the last Ovens of Brittany closed, Mark McKean got out of the restaurant business and shifted into real estate and accounting ventures. Meanwhile, other Ovens players continued to be key in Madison's food scene, among them Odessa Piper, Jane Capito and David Yankovich.

Odessa Piper, of course, opened L'Etoile, which has a history all its own as Madison's finest restaurant. Jane Capito's influence also shoots through some of Madison's most genuine eateries. She ran Botticelli's from 1991 until 1997 while also working in partnership with Anna Alberici at Greenbush Bar and Wild Iris, and with Daniel Altschul on plans for Baldwin Street Grille. (Years later, two younger Altschuls, Gil and Ben, would open key spots in the new generation of eateries, Grampa's Pizzeria and Tip Top Tavern, respectively.) Capito sold Botticelli's in 1997 and sunk her teeth into two major projects on Williamson Street: the revitalization of Mickey's Tavern and the transformation of Mother's Pub into Lazy Jane's.

Lazy Jane's is one place to look for the best morning buns in Madison. The other is La Brioche True Food, where David Yankovich of the original Phoenix group landed. After leaving Ovens in 1981, he worked at various food service jobs. In 1987, he bought a Swiss bakery called La Brioche that John and Antoinette Moret had opened at 115 State Street. After about six good years there, La Brioche moved to a strip mall space on Midvale Boulevard and also briefly had a second location in Monona. Ten years later, in 2008, Yankovich and his wife, Jackie Patricia, moved again and opened La Brioche True Food at 2862 University Avenue, four blocks east of the site of the last Ovens.

Jo Anna Guthrie, the spiritual founder of the Ovens of Brittany, had one of the hardest roads of anyone in its story. Judith Davidoff's February

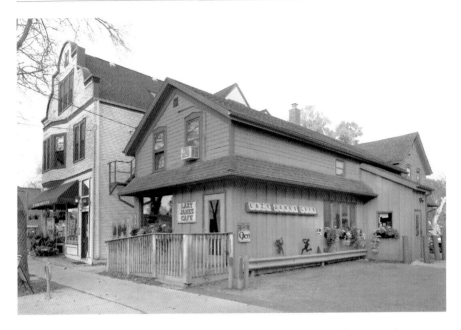

Jane Capito spent a year turning Mother's Pub, a tavern in a nineteenth-century house at 1358 Williamson Street, into Lazy Jane's.

2000 article for *Isthmus*, "Whatever Happened to Jo Anna Guthrie?" told of Guthrie's hospitalization in the mid-1970s and her subsequent falling out of contact with family and friends. Her son Robert Ibarra was an assistant dean of the UW graduate school when she reached out to him again in the early 1980s. She was back in her home state, receiving occasional treatment and living on and off the streets. She died in January 2000 in Springfield, Ohio, still believing she owned the Ovens of Brittany and not realizing that she had become Madison's culinary godmother.

OVENS' LEGACY
L'ETOILE

L'Etoile has the well-earned reputation as Madison's best fine-dining restaurant. Born in the cloud of dust kicked up by Ovens of Brittany's mid-'70s crisis, it opened around the same time as greasy stalwarts Dotty Dumpling's Dowry, Rocky Rococo's and Parthenon. But Madisonians were beginning to develop an appetite for fresher, more sophisticated fare. Odessa

Piper's vision drew like-minded staff and even farmers into its orbit, and L'Etoile quickly grew into its own.

Piper grew up in an old New England farmhouse, one of five children in a family that had a love of foraging and gathering food in the woods and at the shoreline. She left high school to follow an antiwar protester to the Wooden Shoe commune in Canaan, New Hampshire, and then hitchhiked to the Midwest and hooked up with the Phoenix fellowship. Her inclination toward food then landed her at Ovens of Brittany.

The historic red stone building at 25 North Pinckney that was to become L'Etoile's first location had been a department store until 1973, when Andrea's opened there. Andrea Craig had also worked at Ovens of Brittany and studied culinary arts in France. She and her husband, Bruce, did extensive remodeling of the long, narrow space above the Perfume Shop and opened their restaurant with a three-course menu Piper admired in the November 2014 issue of *Madison Magazine* as a "French version of food poetry." Andrea's quickly gained a good reputation but closed abruptly on July 7, 1976.

L'Etoile's first night was a few weeks later, on Saturday, August 8. Odessa Piper and Jim Casey, former wine steward at Ovens of Brittany, jumped at the chance to occupy the former Andrea's space. They brought with them eight other Ovens alumni yet stressed to critic Herbert Kubly that it was an entirely different operation from Ovens. Kubly gave the youthful staff high marks for their sincerity. He noted that the kitchen was rather heavy-handed with herbs and spices. He also mentioned the Madison Independent Workers' Union (MIWU) flyer that another sincere young woman had handed him on his way up the long, narrow staircase to the restaurant. In December 1975, the management of Andrea's had voluntarily recognized MIWU. When Andrea's closed, the union had called upon L'Etoile to rehire the staff. This didn't happen, and so MIWU continued informational picketing of the new restaurant through the first few months of its operation.

Piper hired Elka Gilmore as a chef while she continued to bake and began in earnest to cultivate her relationships with farmers at the growing Dane County Farmers' Market. Jim Casey, meanwhile, booked jazz bands that generally led to diners' early departure. By 1980, Casey and Gilmore had also left. Piper brought in Larry Dial, a nouvelle cuisine chef from Chicago whose efforts to mold the "amateur" L'Etoile staff into a regimented clockwork operation were not well received.

So Gilmore's return to the kitchen in 1981 could perhaps be considered the beginning of L'Etoile's ascent. The 1980s and 1990s saw recognition

beyond Madison for the work L'Etoile was doing with fresh farm products. Chefs Jim Spaeth, Eric Rupert, Brian Boehm, Bob Miller, Susan Lindeborg, Greg Upward and Wave Kasprzak and head forager Tami Lax continued to contribute as Piper's reputation blossomed as documented by features in *Food and Wine, Eating Well, Sierra* and *Bon Appétit*. Piper was involved early on in Chef's Collaborative 2000, a national lobbying group for sustainable food and agriculture, and had a seemingly endless reserve of energy for boosting local farm-to-table activities.

The 2000s opened on new heights for L'Etoile. In 2001, Piper won the James Beard Best Chef: Midwest award. Her signature dish, widely admired in the press from *Madison Magazine* to *Gourmet*, featured the idea of "cooking in octaves" and perfectly captured harvest time in Wisconsin, right down to the adaptable recipe. Four (or Three) Generations of Squash was a dish consisting of a frittered squash blossom stuffed with pumpkinseed pesto (or cheese), set on thin slices of squash and garnished with cold-pressed kurbis oil (or toasted pumpkin seeds).

In 2002, L'Etoile Bakery Market Cafe put out its banner. The Perfume Shop had vacated the ground-floor space in the mid-1990s, and so by July 1995, L'Etoile was able to open a café there. The new kitchen made it possible to offer "Cooking for the Seasons" classes on a regular basis. Also in 2002, Tory Miller joined the staff. A Racine native, he grew up around kitchens; his grandparents owned the Park-In Drive-In on Douglas Avenue. Miller had sought his chops in New York City as sous chef at the prestigious 11 Madison Park and junior sous chef at Judson Grill, returning to Wisconsin to land at L'Etoile.

Piper took Miller on as a protégé from the start and ramped down her own involvement at the restaurant, splitting her time between Madison and Maryland. In 2003, she sold the building to Sonya Newenhouse of Madison Environmental Group, who "eco-refurbished" it. Then on May 5, 2005, Tory Miller and his sister, Traci, bought the restaurant itself. The next decade was full of activity for Miller; soon after the transition, the first-floor café was renamed Café Soleil, offering casual breakfast and lunch fare, as well as L'Etoile's famous bakery. Five years later, the Millers announced a major change: L'Etoile was to decamp from its intimate perch on Pinckney to a glass-walled, ground-floor spot in the U.S. Bank building. It would keep a casual-dining option, called Graze, and its emphasis on local foods and farms. The new L'Etoile opened on July 23, 2010, to great acclaim. Within a year, Tory Miller had gotten his own nod from the James Beard Foundation through tireless innovation, event planning and outreach, including his

own take on chef networking, named the Madison Area Chefs Network. In September 2014, Miller opened his next restaurant, Asian-influenced Sujeo, and in December, he announced plans for his fourth, Estrellón, in a new luxury apartment building under construction at 309 West Johnson Street. The sky continues to be the limit for L'Etoile and its satellites.

8
THREE SQUARE MEALS

I f a person had only one day to visit Madison and grasp a bit of what the city has to offer, food-wise, a visit to three restaurants could provide him or her a decent overview with a historical twist (and probably several days' worth of food). Mickies, Sunprint or Sunroom and Samba (OK, OK, that's technically four) each bring something to the table. Mickies Dairy Bar is a classic diner with guts, in business near Camp Randall Stadium since 1946. Sunprint and Sunroom epitomize a casual café style that dawned in Madison in the 1990s. And spectacular Samba, while offering ostentatious Brazilian-style fare that has little inherent connection to Wisconsin, does so in the beautiful setting of the 1907 Madison Woman's Club building.

BREAKFAST
MICKIES DAIRY BAR

On Saturday mornings, especially on Badger football game days, there's a line out the door at Mickies, and a parade of glassy-eyed eaters clutch to-go containers as they exit. Many undergrads cite this over-the-top mom-and-pop eatery for its low cost to calories ratio.

The brick building at 1511 Monroe Street was designed by Frank Riley and built in 1916. The Pharo Heating Company and the Stadium Pharmacy did business there before Mickies Dairy Bar and Delicatessen opened by May

Mickies Dairy Bar at 1511 Monroe Street on an uncharacteristically quiet morning.

1946. Evan ("Van") Reese and Andrew P. Weidemann worked at Gisholt Machine before going into business together and buying the building, which included three flats behind the store. They named it "Mickies" after Weidemann's wife, Marie. Though the apostrophe has come and gone, the restaurant itself remains a rock solid part of Madison food lore.

Newspaper ads in the 1950s touted Mickies' "real home cookin'" with tenderloin or roast chicken dinners for one dollar. The small grocery and deli provided "one stop shop and lunch," and the long hours—6:30 a.m. to 1:00 a.m. daily—suited college students well.

When Mickie and Andy left Madison in 1955 for Ventura, California, Van brought on a new partner, Norman Bass. Van's nephew Henry ("Hank") Reese, a World War II veteran, dropped out of law school to work at Mickies; he lived near the restaurant and was there almost every day through two changes of ownership until his death in April 2008.

In 1979, Van Reese sold to Debbie and Mark Percy. They kept the small grocery and expanded the lunch menu with soups and fresh bakery. They gradually reduced the evening hours as the demands of their family, and the neighborhood's demographics, changed. Soon the Percys decided to move on entirely. Another Madison institution, Dotty Dumpling's Dowry, briefly considered relocating to Mickies' space. But those plans fell through, and new owners Janet and Payow Thongnuam ended up taking over and retained, or improved, almost everything but the grocery.

Payow was a graduate of Madison Area Technical College's culinary program with chef experience at Hoffman House and deep loyalty that led him to decline an offer from an Alabama developer who offered to buy Mickies in 2006. Everything on the block northeast of Mickies became HotelRED, boutique lodging catering to Badger fans, with a stylish restaurant called the

Wise on the ground floor. Southwest of Mickies, Stadium Barbers and New Orleans Take-Out remain.

Inside Mickies today there's seating at the counter, in wooden booths or at tables with tall stools. Covering the walls are sports paraphernalia and menus, some from much earlier days offering "coffee for a quarter." Mickies is known for its scramblers. These are massive platters of breakfast food that can easily feed two average adults or one linebacker, engineered to kill a hangover or fuel a day of jumping around and cheering the Badgers. And Mickies wouldn't be a dairy bar without malts and shakes, and it does them well in eight flavors, including the usual fruits, plus butterscotch, mint and coffee.

The classic Mickies breakfast isn't only a tradition for students but for some residents as well. Over nearly seventy years, folks from Madison past and present have made memories in that place.

LUNCH
SUNPRINT, SUNPORCH AND SUNROOM

Anyone who ate out at all in Madison in the 1990s would likely have eaten at Sunprint, the result of a collaboration between two very different but complementary personalities. Rena Gelman and Linda Derrickson went into business together in 1984 and went their separate ways in 1992, but Sunprint and its successors made an indelible impression on Madison. On July 15, 2000, *Capital Times* food critic Michael Muckian wrote of the split that it "helped cement what might be called, for lack of a better term, the 'Madison Café' style of restaurants: casual yet classy settings, moderately priced, innovative dishes made from fresh ingredients and the ability to loll over coffee and scones for an indefinite period of time." While Gelman and Derrickson have moved on to projects as different as their backgrounds, their "Madison café style" is still evident. Their direct heirs, Sunroom Café and Sunprint on the Square, operate under new ownership but similar values. Many newer local eateries such as Daisy Cafe & Cupcakery, Marigold Kitchen and Short Stack Eatery could be said to embody the Sunprint style.

The second story of 638 State Street, once the Fanny Garver Gallery, had a grand opening in September 1976 as Sunprint Gallery. Photographer JoAnne Easton and Swiss baker Heidi Haeberli ran the photography studio and display space and served European-style coffee and light snacks.

The innovative idea grabbed the attention of Rena Gelman and Linda Derrickson, who bought the business in 1984.

Derrickson started a small grocery at 334 Lakeside Street in 1982 that stocked everything from "Twinkies to tofu." Gelman came from a teaching and administrative background in New York via the University of Wisconsin and was looking for a challenge. They transformed the gallery-with-food into a restaurant-with-art, combining a fast-food service approach with high-quality local ingredients and a creative menu emphasizing healthful, light meals and decadent desserts.

The combination worked. By September 1987, a second Sunprint opened at 2701 University Avenue. The space had been a supermarket for over forty years (built as a "20th Century Supermarket" in 1941 and then spending several years as a Piggly Wiggly before finally closing in 1986 as El Rancho) and was completely revamped by architect Ed Linville.

Derrickson and Gelman parted ways in 1992. Derrickson and her husband, Mark Kessenich, bought Gelman's share of the University Avenue Sunprint and renamed it Sunporch Cafe and Gallery while Gelman kept the State Street Sunprint. Sunporch employed some creative chefs in the mid-1990s, and much of its food was supplied directly from Derrickson's Mount Horeb farm. Derrickson and Kessenich also ran the Homestead Restaurant and Gift Shop, a charming 1901 structure that had once stood at the end of a railway line and operated as the New America House hotel. In February 1994, Derrickson and Kessenich opened a restaurant there named Moen Creek, bringing on chef Pat Matthews of Heidel House to develop a "farm inspired gourmet" menu featuring game and novelty meats such as buffalo, elk and pheasant. Described in retrospect as "interesting but painfully expensive," it failed to gain traction and closed within six months.

On the very same page of the newspaper that announced Moen Creek's shuttering, an article appeared describing Rena Gelman's speech at the White House Conference on Small Business in Milwaukee. It was the era of expansion of federal small business loans, which was making more restaurant launches possible. Sunprint on State Street had indeed thrived in that environment. In 1992, Gelman hired Pete Vogel of the Vogel Brothers construction company, a Madison institution, to do a major renovation. They were surprised and delighted to find a historical connection: an original support beam was stamped with Vogel's great-grandfather's name, showing that he had been one of the building's original builders in 1928.

In 1995, Gelman sold the State Street Sunprint to longtime employee Mark Paradise, who renamed it Sunroom. She then focused on the other

Sunprint, which opened in 1994 next to one of the original Victor's coffeehouses at 704 South Whitney Way. Ed Linville pitched in again to turn the former home of Babe's Sports Bar and Grill into an appealing cosmopolitan café, and chef Robert Cleary from Clay Market Cafe in Cambridge took the menu to new heights. The Sunprint on Whitney Way thrived until November 2004. The space became Cancun Mexican Restaurant in 2005 and then Nonno's Ristorante Italiano in 2013.

In February 2003, Gelman and partner Robert Lauer had also opened Sunprint on the Square at 1 South Pinckney, in the cafeteria space vacated by Milwaukee-based Heinemann's. Susan Hendrix and her husband, Jason, took over operation of Sunprint on the Square in 2007, and in April 2013, they moved out of the massive, glassy space on Pinckney and into a cozier spot at 10 West Mifflin.

Sunporch, meanwhile, had gone up for sale in 1999 when Derrickson became treasurer for the town of Vermont, where she continued to operate Moen Creek Farm and the Othala Valley Inn Bed & Breakfast. Sunporch was purchased by Barbara Golden, who also ran the Little Village restaurant at 211 King Street. Golden renamed it Samantha's Sunporch, and it closed after less than three years. Food Fight took over the storefront at 2701

Sunprint on the Square epitomizes the "Madison café" style.

Sunroom Café on State Street serves fast, affordable and locally sourced meals.

University, pursuing three themes there. First was Firefly Asian Fusion from 2004 to 2007. Then a second Tex Tubb's Taco Palace came in until 2010, and finally, after messing around with the names "Cadillac Ranch" and "Cactus Ranch," even Food Fight surrendered. An Einstein Bros. Bagels moved in, perhaps enjoying more stability because of its position on the right side of the street to serve morning commuters—and those wanting to loll over coffee.

DINNER
SAMBA

The historic Woman's Building at 240 West Gilman was built for the Woman's Club of Madison. Incorporated in April 1893, the club was part of a movement sweeping the country in the decades before women won the right to vote in 1920. In Madison, the club idea was fostered by a handful of

Samba, in the 1907 Woman's Club building, has a Beaux-Arts floorplan with its main level on the second story instead of the ground floor.

influential women including Mary Louisa Atwood (wife of David Atwood, the founder of the *Wisconsin State Journal*), Mary Adams (wife of University of Wisconsin president Charles Kendall Adams) and Belle LaFollette (wife of "Fighting Bob"). The Woman's Club predated the more business-oriented Madison Club, which was founded in 1909 and did not open its membership to women until the 1970s. The causes the club espoused were most often those of the Progressive movement: public health, education and cultural enrichment. As for food issues, the Woman's Club fought for milk inspection and quality school lunches.

In 1905, the club started plans to build a clubhouse, and by 1907, the new building was ready for occupancy. Architect Jeremiah Kiersted Cady from Chicago designed the brick building with a mix of Spanish Colonial Revival and Mission Revival styles with Arts and Crafts details and windows. The clubhouse featured a formal auditorium, meeting rooms and "dainty and complete kitchen and pantry equipment" to serve teas and luncheons for the club women.

In 1973, the Woman's Club sold the building to InterVarsity Christian Fellowship, which used the facility until 1986. Reed Design then took up occupancy, making some renovations and adding a stucco facing to the exterior. By 1990, the design firm had left and Avol's Bookstore opened in the space. It lost its lease in 2004 after real estate developer Joe McCormick bought the building and proposed to demolish it to erect a six-story condominium development.

This move electrified the community. The "Save the Woman's Building" organization sprang into being and fought alongside the Wisconsin Trust for Historic Preservation to retain the structure. They succeeded in getting historic landmark status in 2004, and McCormick's company sold the building in 2006 to Jongyean Lee for $3 million. Lee and her husband, Hyungirl, were big in the liquor and restaurant trade downtown, operating Brickhouse BBQ, Riley's Wines of the World and the Church Key bar.

Jongyean invested another $1 million in renovations and made plans to open two restaurants in the building in early 2007. The plans were held up by liquor licensing and neighborhood concerns over attracting rowdy crowds, but the character of the project was ultimately more upscale. The Lees' conscientious renovation was received warmly when the first-floor casual café Cabana Room opened in November 2007. When the Brazilian steakhouse Samba opened upstairs that December, Madison gained a breathtakingly beautiful restaurant.

Lee also made a shrewd decision bringing in Joe Tachovsky to run the food operations. Tachovsky had Madison roots as a partner in Second Story and the guy behind Porto Bananas. Porto Bananas quickly lodged itself in Madison's food consciousness despite only being open from August 1986 to November 1988 at 223 King Street, with a second location next to Bahn Thai at 2865 University Avenue. The name came from a misread intertitle in the 1953 Ronald Reagan flick *Tropic Zone*. They served "fun" Mexican food with some extras—blow-up dinosaurs, the featured "Caribbean nation of the week" and a framed portrait of Pee Wee Herman (impressions upon request). According to a December 1987 piece in *Isthmus*, Porto Bananas is where Brooke Shields dined when she came to town.

Tachovsky closed Porto Bananas and headed to Minneapolis from 1987 to 2002 to run a popular place called Chez Bananas, but returned to orchestrate Madison's foray into *rodizio*, a Brazilian style of restaurant service distinguished by all-you-can-eat meat served tableside. At Samba, the "meat waiters" are dressed in hats and sashes and come to the table bearing swords with various cuts of beef, pork and sausage as well as

roasted pineapple. The endless salad bar is extraordinarily well stocked, too, and varied enough to serve as a meal on its own. An average spread might include Marcona almonds, various cheeses and yogurts, hot and cold vegetables, granola, tapenade, garlic toasts, fruit and green salad. At brunch, there are eggs, bacon, pancakes and potatoes. To add more Brazilian flavor, there is always cool green chimichurri to dab onto anything and everything. Feijoada, the black bean and meat stew that is the national dish of Brazil, might also make an appearance. A staple on early menus of the first-floor café, it was abandoned later in favor of a more middle-of-the-road burger and pizza approach.

In 2009, Jongyean and Hyungirl were convicted of tax evasion and were threatened with the loss of the liquor licenses at all of their establishments. They were sentenced to prison but allowed to serve staggered terms and thus were able to keep their businesses open. Tachovsky also left in 2009 to pursue other ventures, including the popular Spot on Johnson Street (opened in 2013 where Mildred's had been), but chefs Mark Walters and Bob Kulow kept the meats roasting and the salad bar stocked.

Over the years, the first-floor café has had several name and theme changes, from Cabana Room to Cafe Samba, then Samba Lounge and most recently Side Door Grill and Tap. Samba, however, seems to be a stable destination dining spot. It is a stalwart of the downtown brunch scene, *Madison Magazine*'s Restaurant Week and winter holidays. Father's Day is an especially big day at the erstwhile Woman's Club, perhaps not surprising for a restaurant trafficking in so much meat.

9
SURROUNDED BY REALITY

If there's one thing that makes Madison Madison, it is that the city is a little "out there," especially for Wisconsin. In the rest of the state, being too "Madison" sometimes describes something that's a little too aloof, a little too liberal or a little too wacky. Here are some restaurant stories that illustrate why this capital city has never needed a "Keep Madison Weird" campaign.

FROM EDDIE BEN ELSON TO KAFE KAHOUTEK

While Mad Dog hot dog cart exploits, the grandiose designs of Kafe Kahoutek, Epic cookery and gourmet Main Street mom-and-pop fare may appear to have little in common, the threads that bind them form a tapestry that is uniquely southern Wisconsin.

In the late 1970s, a small fleet of hot dog carts called Mad Dog was launched in downtown Madison. They were a sideline of Edward Ben Elson, but hardly his only mark on Madison's history. Called a "bon vivant" or "outrageous"—or both—Elson was perpetually in the public eye during his brief but bold life.

Born in New York, Elson graduated law school at UW–Madison. He was a skilled lawyer and advocate for the mentally ill who successfully fought to strike down the state's involuntary commitment law. He also operated the No Hassel head shop on University Avenue near campus in the late 1960s.

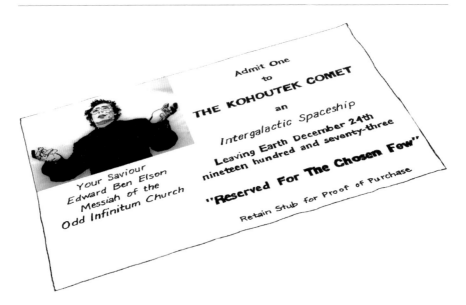

Illustration by Kayla Morelli from ticket by Eddie Ben Elson with photograph by Robb Johnson.

A "perennial candidate" for various offices—mayor of Madison, district attorney, Dane County judge, and state superintendent of schools—his platform was simply "just obey good laws," and he never ceased poking fun at the establishment.

He made national headlines in 1973. It was the year of the Comet Kohoutek, the "comet of the century," which was making its first approach to Earth. Astronomers expected it to appear in the sky around Christmas in a blaze of bright light visible to the naked eye, and public interest was captivated. In November, Elson claimed he had a vision of a cosmic visitor that told him Kohoutek would hover over his pier on Lake Waubesa in McFarland. The comet would rescue 144,000 miniaturized Earthlings before its tail destroyed the planet, and the visitor invited him to bring along one thousand people of his choosing. So he printed up tickets. He gave away half of them and then announced that he would sell the remaining tickets for ten dollars (the price rose to one hundred dollars as Christmas approached).

Comet Kohoutek's arrival turned out to be modest, to say the least. Some newspapers ran totally black boxes as joke "photographs" of the comet in the night sky. Elson's tickets weren't guaranteed, but luckily for everyone, the comet spared Earth. A few days after Christmas, he appeared in court to settle a parking violation. He offered the judge a Kohoutek ticket, whereupon

the judge asked if it wasn't too late to use—so Elson signed the back to "validate" the ticket for another ten days.

In 1977, Elson mortgaged his home to purchase a number of mobile pushcarts and start a hot dog business around the Capitol Square. The low-tech nature of the Mad Dog carts drew negative attention from local officials, who complained to the state health department, which took Elson to court in 1978 to enjoin him to outfit the carts with plumbing and refrigeration systems. Elson argued that it would be prohibitively expensive to do so. Attorney General Bronson LaFollette (a friend whose roaming Irish setter Cutter had been represented in a leash law case) ruled in Elson's favor, arguing that hot dog assembly and garnishing was not a sufficiently complicated culinary process to require the same food safety standards demanded of a restaurant. Mad Dog carts were popular for the next several years, even participating in early Taste of Madison events.

Elson continued his vigorous legal career and stayed in the public eye. Tragically, he committed suicide in February 1983. His mark on Madison culture was so strong that decades later, journalists and cultural observers still often compare any whimsical, charismatic shenanigans to those of Eddie Ben Elson.

In 1994, plans were announced for a new entertainment complex in the breathtaking but troubled space in the Madison Depot at 640 West Washington Avenue, near Hotel Washington. Formerly a Crandall's and briefly the Hiawatha Club, the space was to be home to three restaurants: Kafe Kahoutek (with an *a*), an upscale venue called Eric & Etienne and a gourmet New York–style bakery and deli. The theme of Kafe Kahoutek's décor was to be "galactic," with a forty-foot model of the comet suspended over the dining area—and a shrine to Eddie Ben Elson in one alcove.

Behind the idea was Stephen Weber, the maitre d' at L'Etoile and a former manager of Steak and Ale franchises in New Jersey and Pennsylvania. Chefs Eric Rupert, a partner in the business, and Dave "Wave" Kasprzak, also hailed from L'Etoile. Rupert had started as baker at Ovens of Brittany and moved to Madison Club in 1987; Kasprzak had been kitchen manager at Quivey's Grove. Given the experienced crew and the grand theme, the plans were announced with great confidence, but ultimately, the venture didn't catch on. New Year's Eve 1996 found Kafe Kahoutek closed, and its customers—and kitchen staff—left out in the cold. Gift certificates bought as Christmas presents were as useless as tickets for flying saucer rides.

Chef Eric Rupert went on to esteemed positions at Atlas Cafe, Opera House and again at L'Etoile before joining Epic, the electronic health

record software company, to feed its army of highly skilled workers. Epic's corporate campus in Verona, just southwest of Madison, is ever expanding and is not short on whimsy. Its themed buildings range from faux bucolic to science fiction fantasies. In 2009, the first building raised on Campus 2 was an Asian-themed structure named Kohoutek.

Wave Kasprzak likewise went on to good things. After some time at Deb and Lola's on upper State Street, he and his wife, Jane Sybers (also from L'Etoile), opened The Dining Room at 209 Main in Monticello, near New Glarus in Green County. In 1996, Monticello was a fairly average small Wisconsin town with the attendant main street malaise. But the Monticello Business and Professional Association took a vigorous approach to making improvements. One move was by Ruth Sybers, Jane's mother and a retired professor of economics, who bought the building in the 200 block of Main Street. The 1910 brick building was once the Monticello Pharmacy and more recently a typical tavern called Village Tap. The Sybers and Kasprzak did extensive renovations and painting inside and out.

The Dining Room's grand opening on September 25, 1996, began a long and successful stretch of fine dining. The menu is sophisticated, spicy and seasonal. The staff is usually family, with Jane Sybers hosting and Pat Kasprzak waiting tables. Lovingly curated textile art displays complement the experience. The wine list has received *Wine Spectator* honors for more than a decade, and Kasprzak's recipes and stories were collected in a cookbook titled *It Takes More Than a Chef*.

LORRAINE'S CAFE, FRIENDS CAFE, BOEHM'S, ENDLESS PASTABILITIES, DESSERT HEARTS, GREEN GODDESS, SAVORY THYMES AND THE SECOND LAO LAAN-XANG

Another tale of Madison food culture unfolded in a humble red brick building at 1146 Williamson Street. The boomtown-style building has housed a number of businesses since it was built in 1902. In the 1930s, the Roseland Inn served fish frys and spaghetti dinners. For a few decades after it closed in 1936, a radio and appliance repair shop ran there, with apartments for rent on the second floor. It was the first site of Sy and Ruth Levey's beloved Rock-A-Bye children's clothing store. And in 1960, it became a restaurant again as the Pancake House, prelude to a string of truly memorable Madison eateries.

In 1964, Lorraine Mongold was working as a nurse and living in one of the apartments in the building with the little ten-seat breakfast café. In her 1979 autobiography, *The Angel of Williamson Street* (also the title of a November 3, 1972 *Wisconsin State Journal* feature), she describes how she overcame her own challenges and the strong drive this gave her to help others. So when an opportunity to buy the café came up, she took it, intending "to set this little café up and use it to rehabilitate alcoholics by letting them run it." By 1967, Lorraine's Cafe was running daily from breakfast to suppertime with Mongold as the only permanent employee.

In addition to her constant presence at the café, she contributed to countless causes, including the establishment of the Near East Side Health Center, the Wil-Mar neighborhood center and Hope Haven. She was a force at Madison Urban Ministry and her home church First United Methodist, as well as a behind-the-scenes worker at the holiday events at the Wisconsin Rescue Mission and the Church of the Helping Hand.

She was rarely quiet, however; in neighborhood affairs she had a reputation as an outspoken activist. For instance, when a Taco John's franchise set up at the corner of Brearly and Williamson in 1976, she told the newspaper that the neighborhood should give the business a chance. In this, she was almost alone. The fast-food spot was razed shortly after it opened, and today, the site is a landscaped green space.

Lorraine's Cafe faced financial challenges even its angel couldn't forestall forever. The restaurant's last day was February 17, 1978, but it was not the end of interesting times at 1146 Williamson. Until 1997, when Lao Laan-Xang moved in and brought its established west side fan base, the space hosted a half dozen businesses and at least that many food ideologies.

First was the Friends Cafe. Brothers Jim and John Uhalt were sawmill owners from Sun Prairie and admirers of Lorraine Mongold's work. They sought to save the community spirit of the café and brought in reggae, Rastafarianism and vegetarian fare, as well as their real-live lion cub mascot named Sphynx.

In about 1982, Boehm's Restaurant moved in. It served a mix of Italian and Indian dishes for dinner only. A review in the *Wisconsin State Journal* of April 3, 1985, described it as a "classy little restaurant" and praised its use of free-range chickens. It lasted until the mid-'80s. In 1990, the short stay of Endless Pastabilities ended with a fire in a box of oily rags. Dessert Hearts Cafe and Green Goddess garnered some critical praise as epitomes of Willy Street style, but both were gone by 1992.

Savory Thymes gained some fast traction in that spot. Opening on February 24, 1992, without much advertising, the vegetarian restaurant

soon had a loyal following. Chef Amy Milanich's food was the draw. Her background included Nature's Bakery, L'Etoile and an education at New York's whole foods cooking school, Natural Gourmet. "Locally, organically grown produce is at the heart of the restaurant's seasonal menu," stated a review in the *Capital Times* of July 4, 1992. Though this approach to food was becoming more common, it still required explanation. For example, in 1994's *Capital Times* "Cornucopia awards," Savory Thymes got a nod for "most politically correct dining," citing the restaurant's use of organic Steep & Brew coffee, free-range chickens and filtered water.

Savory Thymes changed hands in early May 1995, when Kristin Susnar, Bob Weinswig and Mary White took over. They kept many of the same recipes, but Bob redecorated the dining room in attention-grabbing colors. Though the restaurant earned a national nod in the October 1997 issue of *Vegetarian Times*, it was already near the end of its run. Weinswig announced that month that he and Susnar had been quietly trying to sell for over a year. The new operator would be Christine Inthachith of Lao Laan-Xang.

Inthachith was not yet twenty years old when she appeared on the restaurant scene. A driven and talented woman, she immigrated to the United States from Laos with her family, headed by her mother, Bounyong, in 1980. She graduated from high school early, and while she was a freshman at UW–Madison, opened Lao Laan-Xang in a strip mall at 6824 Odana Road in 1990.

Lao Laan-Xang was Madison's first Lao restaurant, introducing residents to sticky rice and laab, the spicy beef salad. Bounyong's cooking was the key to its popularity, and two of Christine's brothers helped keep things running. Lao Laan-Xang operated in its original location until 1994, when it took a brief hiatus. It returned in 1997 at 1146 Williamson. The new location (still using Weinswig's palette) was very successful, and in 2004, a second Lao Laan-Xang opened at 2098 Atwood Avenue.

The trajectory of Thai food in Madison followed a similar west-to-east arc and was also instrumental in Williamson Street's transformation. Bahn Thai was the first Thai restaurant in Madison and opened in November 1984 at 2809 University Avenue. Dr. Terry Buchli, a veterinarian who was introduced to Thai food during his army service, worked with manager Atcharaphan "Atchi" Kluge and her mother, Sudsawat Knight, who did the cooking.

Bahn Thai's second location opened in Third Lake Market strip mall at 944 Williamson Street on Valentine's Day 1988. At the time, Willy Street was suffering what Joe Lusson described in the *Wisconsin State Journal* of May 17, 1989, as an "image problem, not a reality problem" that neighborhood

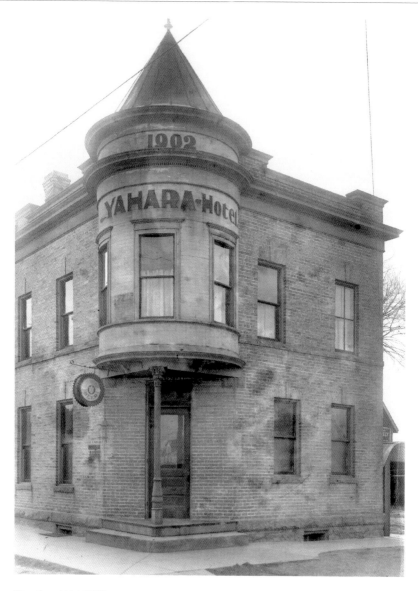

Number 1524 Williamson Street was once the site of Eliphalet Fuller's hotel. In 1902, the Yahara Hotel replaced it, and in 1997, Jane Capito opened Mickey's Tavern there. *Wisconsin Historical Society, WHS-52194.*

business owners and nonprofits sought to ameliorate. Bahn Thai's popularity at its established west side location was an asset, and the restaurant proved to be in the vanguard of Willy Street businesses that gradually led to its evolution into a major commercial and culinary artery. Twenty-five years

MADISON FOOD

later, the street is cheek to jowl with nose-to-tail hotspots: Underground Butcher for meat; Batch Bakehouse and Madison Sourdough (another west-to-east transplant) for bread; the Capito/Altschul cluster of Lazy Jane's, Grampa's Pizzeria and Mickey's; plus Umami, A Pig in a Fur Coat, Weary Traveler and Ha Long Bay.

EAST WASHINGTON AVENUE

The next big thing in the Madison culinary scene appears to be the East Washington Avenue corridor. Many massive mixed-use projects hit the wire in the mid-2010s. These plans were often anchored by the promise of nightlife and fine dining. For example, the Constellation development in the 700 block of East Washington introduced Tory Miller's Korean-fusion Sujeo and the swanky Star Bar. The transformation from highway to high rollers promises to be dramatic, but two bastions of Madison lore remain on the avenue: Bellini and Ella's.

Bellini is the last remaining restaurant in the Gargano family, a dynasty that deserves a place of honor at the Madison table. It began when Carlo Caputo (of Carlo's Pizzeria, since 1955 a popular spot in the 600 block of State Street) brought his nephews, Virginio, Giuseppe and Biagio Gargano (of Gino's, Peppino's and Bellini, respectively), to the United States from Sicily, where the family grew lemons and later olives.

Virginio Gargano came to Madison in 1962 and opened Gino's at 535 State Street on July 5, 1963. Four years later, it moved across the street to 540, where it spent the rest of its tenure and eventually expanded to delis in Middleton and on the southwest side. Gino's was beloved of students, politicians and just about everyone else in Madison, particularly for its lasagna and stuffed pizza. Mayor Soglin even declared its fiftieth anniversary on July 5, 2013, to be "Gino's Restaurant Day."

Giuseppe "Peppino" Gargano, the youngest brother, settled in Madison in 1967 with the dream of bringing fine Italian dining to a city that knew little beyond meatballs and pizza. In 1974, Peppino opened his first restaurant in the second-story space that was formerly Gino's family's living quarters. Peppino's moved to 5518 University Avenue in 1980 and then in 1998 truly came into its own in the Jackman building at 111 South Hamilton. This Madison landmark provided an elegant atmosphere for Peppino's refined Italian dishes. In 2009, Peppino retired, and soon thereafter two

128

It'Sugar and Kabul moved into 540 State Street after Gino Gargano retired and closed Gino's on October 31, 2014.

The Jackman building, home to Peppino's and then Nostrano, dates to 1913 and was designed by architects Claude & Starck.

renowned Chicago chefs, Tim and Elizabeth Dahl, opened their farm-to-table Nostrano.

Biagio, the eldest brother, got into the restaurant business in 1962 with a pizzeria called Giuseppe's at 318 Randall Street. He later moved his pizza parlor to 401 State Street and changed the name to Gargano's. In 1979, at the beginning of a citywide boom in theme restaurants such as Showbiz Pizza and Ground Round, Biagio bought the Our Savior Lutheran Church building at 401 East Washington Avenue. He renovated the 1897 structure at a cost of a quarter million dollars, decked his servers in monk's robes and opened the Monastery Restaurant in 1980. The Monastery made *Madison Magazine*'s "best place to take your mother" list. It was soon joined by Essen Haus in the (unofficial) list of "places with goofy outfits for servers." Biagio decided to retire and closed the Monastery in 1994. For a brief interlude, Roderick Bott and chef Billy Horzuesky ran an establishment called Cornerstone there, but Gargano got back into the business with Bellini in 1998. The next generation

The nineteenth-century church building at East Washington and South Hancock Streets has been in use as a restaurant since 1980.

Ella's lively entryway welcomes kids of all ages.

(Peter and Angelina Gargano and Maria Gargano-Nolan) runs Bellini today, serving good Italian food in a refined but unique atmosphere, minus the robes.

The stories intertwined with Ella's demonstrate the intersection of diverse paths and a quirky spirit that is quintessentially Madison. Open since 1976,

the current East Washington location was Ella's Deli's second. The first was at 425 State Street.

Before its four decades as a deli and restaurant, the storefront at 425 State had been for thirty years a grocery. Prior to that, a succession of student-centric diners had held sway going back to at least 1908. At that time, Miss Helena Preiss ran The "U.W." Restaurant, where a dinner cost twenty cents or loyal customers could get eleven for two dollars. "U.W." was followed by the College Inn and then the Badger Restaurant. In November 1909, confectioner Al J. Schwoegler, "the original Bitter Sweet king," branched out from Keeley's Palace of Sweets and opened his own store, advertising its "cozy little booths that are a new innovation in this city." Nicknamed "the Cozy," his candy shop enchanted students for almost a decade.

In 1918, "Chilly Al" Felly ran his Wisconsin Lunch there. Felly, once a line rider on King Ranch in Texas, brought back to Madison his "secret Aztec recipe," and it was a hit—so much so that wanted gangster John Whitfield brought his girlfriend to Al's for lunch one day. Al called the police, but Whitfield slipped away, only to be apprehended in Cleveland; Al testified against Whitfield and used the $600 reward to open the beloved Felly's at 2827 Atwood Avenue in about 1929. His wife, Lydia, operated this location from Al's death in 1937 until 1943.

Back at 425 State Street, in 1920 Chester A. Pledger had opened the State Street Cafe, which quickly turned into Tom Yaka's W Cafe. In 1930, it was converted into the Mack-Olson Food Shop, which it remained until Marty Rosen opened his delicatessen in 1960. Around that time, Ella Hirschfeld was running the kosher food service at UW Hillel, to great acclaim. The rabbi encouraged her to go into business for herself, and so on July 4, 1963, she opened Ella's Deli, selling groceries and serving classic dishes like borscht, blintzes and corned beef. A short four years later, she retired to Florida with her husband Harry and sold Ella's to Nathan "Nat" Balkin.

Balkin and his son Ken brought Ella's into a new era. The year 1976 was the beginning of the East Washington location, operated by Ken in a former mobile home showroom. Two years later, Nat added an old-fashioned soda fountain to the State Street location while retaining the traditional deli features. Ella's gradually expanded into the adjoining addresses, absorbing Bluteau's Meat Market where Gordon Hocking (husband of original Ella's server Bonnie) worked.

Meanwhile, out on the east side, Ken Balkin was living a dream. Ella's had become a showcase for colorful motorized contraptions, from airplanes to bandstands, and barely disguised characters from comics and cartoons. In

Nat Balkin introduced the famous #1 Grilled Pound Cake–Hot Fudge Sundae around 1978 at the State Street Ella's Deli.

summer of 1982, Ken Balkin introduced a new Madison landmark: a classic carousel. It was one of fewer than seventy-five operating in the entire country at that time. He picked up the carousel itself in North Tonawanda, New York, and the horses came from Cincinnati. After painstaking restoration with help from many of Ella's 125 employees, the fabulous ride became quickly beloved of Madisonians young and old.

Back on State Street, Nat sold Ella's to Bonnie and Gordon Hocking, who ran it for the next decade or so. In 1999, it closed after the Hockings sold the business to restaurateur Vasilis Kallias, one-time owner of Mykonos Philly Steaks and Subs. Kallias and Stefan Dandelles kept the staff and most of the menu for their new Cafeli (a portmanteau of café and deli). It was rather short-lived. In 2002, Hawk Schenkel, a former manager at Amy's Cafe and server at Cafe Continental, bought the business and did a total overhaul of the space to open Hawk's, the current tenant of 425 State Street.

A decade later in 2012, the Ella's Deli on East Washington Avenue marked its thirty-sixth year in business, surpassing its parent restaurant in longevity. Though memories of the original Ella's may have begun to

Ken Balkin unveiled the restored 1927 C.W. Parker carousel in 1982 at the East Washington Ella's.

fade, today, Ella's greets visitors to Madison with red neon by night and rainbow hot-air balloon sign by day. In winter, a meal among Ella's dozens of whirling toys and light-up contraptions can be a magical antidote to cabin fever. In summer, the carousel brings its carnival of color to an otherwise drab and chain-heavy highway through a residential area where the down-at-heel and the well-heeled mix. Countless Madison kids have grown up riding the carousel, and some lucky ones can count token taking as their favorite summer job.

10
AROUND THE WORLD IN EIGHT RESTAURANTS

Madison has many fantastic places to eat, and the diversity of influences on its contemporary food scene is sometimes truly stunning. While fusion and American cooking dominate the landscape and are well represented among Madison's most popular restaurants (Old Fashioned, Graze and Monty's Blue Plate leap to mind), the international flavor of a city so small is amazing. Madison provides ample opportunity to sample both the best of Wisconsin and the best of the world. The eight restaurants in this chapter are not Madison's eight best restaurants—compiling such a list would be futile and would not cover even a plurality of situations where a recommendation would be needed. Think of this instead as a brief snapshot centered on some representative places.

NORTH AMERICA
Taqueria Guadalajara

Madison's experience with Mexican food is typical of that of the rest of the state. The first Mexican food arrived in the late 1960s and early '70s with Paco's and Brave Bull, went corporate during the '80s with Chi-Chi's and taco chains and blossomed in the early 2000s to encompass everything from local chains (Laredo's and Cuco's) to food carts (El Burrito Loco) and genuine everyday Mexican food (La Hacienda and Los Gemelos). The best

of these is a Park Street outpost that survived a fire and is still serving quality tacos: Taqueria Guadalajara.

TG is small affair. Just under half the indoor seats surround the cooking space so that you get the full smell and show of good cooking in addition to a tasty taco or burrito. In the summer, there is a patio out the back door for those nights when sitting around a hot grill just won't do.

The fare here tends toward the novel. Tacos can come al pastor or with steak or carnitas, certainly, but *lengua* and *tripa* are also on the meats list. Huaraches and sturdy gorditas are amply filled and arrive at the table hot. Almost everything comes topped with fresh cilantro.

Is Taqueria Guadalajara the best place for tacos in North America? Absolutely not. Madison, even at its zenith, could never compete with states that border Mexico or larger urban centers like Chicago or even Milwaukee. It is, however, the place that best fills Madison's need for quality and quantity in Mexican cuisine, and it does so in a place that feels as laid-back as the land south of the border.

SOUTH AMERICA
INKA HERITAGE

South American restaurants have arrived in Madison since the turn of the last century. The city has seen a new Brazilian steakhouse, several empanada carts (from both Venezuela, and Argentina) and at least two Peruvian places. Inka Heritage, just a few blocks north of Taqueria Guadalajara, was the first. It provides the city's best example of this type of cuisine.

Peruvian food is strongly influenced by Japanese ingredients. So while you can get wonderful chicken and beef, there's also a lot of seafood on the menu. Rice accompanies a lot of dishes, molded tidily instead of in a loose pile.

Many items come served over French fries (not with, over), giving each plate a more playful and casual feel. At Inka Heritage, all of these entrées are well prepared and focus on the protein as the star. The celebrity plate is *pollo a la brasa*, "roast chicken," which comes with three delicious dipping sauces.

The drinks available at Peruvian places are worth mentioning as well. Inka Heritage serves chicha morada, the purple corn beverage, and Inka Kola, the bubblegum-flavored soda.

AFRICA
NILE

Madison lost a true gem when its last East African subterranean eatery and food cart, Buraka, closed in 2014. Most of the African continent is not currently represented, other than at some southern Mediterranean places. Fortunately, Nile is one of those Mediterranean places, and it has great food.

Nile was opened by a manager from LuLu's, a beloved restaurant that was demolished in 2011. In addition to lovingly prepared chicken and lamb shish kabobs, you can get *shawarma* and *kefta mashwee*. Delectable *baba ghanouj* and hummus as good as LuLu's are the real secret of this place. Everything is so carefully crafted that even those who have been to Egypt say that Nile does things right.

MIDDLE EAST
BANZO

Speaking of falafel, Asia is a pretty large continent. Even with two places in this overview, it is way underserved. The Middle East makes a nice breakout section, and Banzo does everything falafel just right.

Starting first as a single food cart, Banzo has since opened a second cart as well as a restaurant on the north side. The carts often park out front to remind you to look for them at events around Madison. In addition to their small but robust menu of sandwiches (including eggplant, chicken and brisket), they serve soups and sides that appeal to even the pickiest eater's palate. At the carts, the pita sandwiches are served in ingenious perforated boxes that allow for eating on the run.

Other Middle Eastern places of note in Madison are the recently relocated Kabul, People's Bakery (fresh donuts *and* Lebanese food, both done well) and Mediterranean Café (which, though open only for weekday lunches, is Madison's best food value, period.)

EUROPE
LA BAGUETTE

Italian and French restaurants dot the Madison scene, from Paisan's to Lombardino's and Chez Nanou to L'Etoile. Instead of trying to evaluate which of these places makes the best pizza (Pizza Brutta or Café Porta Alba) or which one serves the heartiest food (probably German-representative Essen Haus or Irish mainstay Brocach), a small *boulangerie* on the west side is the place that feels the most European.

La Baguette, a transplant from Minocqua in 2008, is very committed to presenting well-made and thoroughly representative fare. Don't be surprised if placing or getting your order takes a little longer. Or if you hear the counter staff conversing in French as well as English. It's all part of the charm. If you want American service, you can head to the almost-as-great bakery Clasen's in Middleton and get a wider range of breads or to Madison Sourdough, the city's elite artisan bakery.

ASIA
HIMAL CHULI

For the rest of Asia, should you go with Russian and that classic standby Paul's Pel'meni? Southeast Asian: Ha Long Bay? Chinese: Imperial Garden? Japanese: Wasabi? Indian: Swagat or Maharani? Vietnamese: Saigon-Noodles?

Instead, here's a place that represents a cuisine not often seen even in large towns. Himal Chuli was Madison's first Nepalese restaurant (of three). Its presence on State Street feels as necessary as State Street Brats, Memorial Library or the capitol.

The best time to visit is in the winter months when the warmth and humidity from the kitchen slicks the entire front window in steam and fog. Plus, there's just something atmospheric about eating warm food from the top of the world while the cold wind whips outside.

The go-to starter at Himal Chuli is the dal. This lentil soup finds exactly the right balance of flavorful and hearty. Follow that with a plethora of vegetarian options, each spiced in a very rich and artful way. Or if meat's your thing, enjoy chicken, lamb or beef, prepared in "buff" or perhaps a chili style. For a place with a small menu, there's always a lot to explore.

OCEANIA
Tuvalu Coffeehouse & Gallery

This is a total cheat. There is no food from Oceania in Madison. Only Outback Steakhouse even pretends to have food from the South Pacific. So instead, consider this small coffee shop in Verona, named for one of the tiny Oceanic countries that no one remembers until a three-athlete delegation bears its standard at the Olympics.

Tuvalu, the coffee shop, despite not being in Madison, has most of the features of a quintessential Madison café and makes a perfect addition here.

- Local, fair trade and organic are not just buzzwords; they are a way of life. The coffee comes from Madison's Just Coffee Cooperative, an organization as committed to fair trade as it is to mixing perfect blends. The tea is from Rishi Tea of Milwaukee.
- It is located quite close to a bike path, convenient for cyclist commuters. Elsewhere, people may think that ten miles on a bike is a long commute; Madisonians disagree.
- The menu, while small, is laser-focused on providing the right balance of flavors. About half the items are for meat eaters, a quarter are vegetarian and a quarter are vegan.
- There is a lot of local art for sale.
- Local and independent musicians swing through a couple times a week to perform intimate shows.
- There are board games, but a few of the pieces are missing.

Similar portraits could be sketched of Johnson Public House, Victory, Froth House, Barriques, Cargo, et al.

GETTING THERE
Pat O'Malley's Jet Room

Pat O'Malley's Jet Room is a diner in the Wisconsin Aviation building at the Dane County Regional Airport, and its windows look right out onto the runway. Hot breakfasts and lunch sandwiches are the standards here, with a classic take on burgers, French toast and omelets. While Madison has some great low-cost eating establishments offering these same products (Curve and Cottage Cafe leap to mind), there's something unique about buttering your toast while a small two-seater alights, and

Pat O'Malley's Jet Room, serving classic American diner fare, opened in 1997 and moved to its current location in 2002.

then the pilot and passenger sit down in the neighboring booth as you finish the last bite of crust.

In addition to some great food, they also have a fully loaded menu full of airplane puns (variations on Eggs Benedict are under the heading "BENNY AT THE JET"). Their plates bear their name and logo, a helpful cue for the jet-lagged.

Visiting these eight restaurants won't turn you into a world traveler, nor will it even offer an eighth of the fine food you can eat in this fair city. But these serve as benchmarks, balancing quality and price with local flavor and international flair.

THE ONE HUNDRED MOST INFLUENTIAL RESTAURANTS IN MADISON HISTORY

This list is entirely subjective.

1. Eben Peck's Tavern Stand (1837–38)
2. St. Julien (1855–86)
3. The Fess Hotel (1858–1994)
4. St. Nicholas (1861–99, 1908–46)
5. Simon House (1883–1939, 1952–71)
6. One Minute Coffee House/Lunch (1899–1928)
7. Columbian Lunch Wagons/Cafe (1902–53)
8. Cleveland's (1909–2008)
9. Chocolate Shop (1914–54)
10. Cop's Cafe (1916–51)
11. Belmont Hotel (1916–68)
12. Rennebohm Drug Store (1916–83)
13. Coney Island (1921–64)
14. Campus Soda Grill (1922–53)
15. Badger Candy Kitchen (1924–2002)
16. Red & White Hamburger System (1926–85)
17. Frenchy's (1927–80)
18. Piper's Cafeteria (1928–57)
19. Felly's (1929–43)
20. Little Dutch Mill (1929–59)
21. Kennedy Manor (1929–2015)

22. Tony Frank's (1932–)
23. Cuba Club (1933–91)
24. The Plaza (1935–)
25. Justo's Club (1936–71)
26. Rohde's (1936–93)
27. The Stamm House (1936–2013)
28. Brown's Restaurant (1938–74)
29. Monona Drive-In (Hungry, Hungry, Hungry)/Big Jon's (1939–94)
30. DiSalvo's Spaghetti House (1941–61)
31. Yee's Chinese American Restaurant (1945–78)
32. Bunky's (1946–62, 2004–)
33. Hoffman House (1946–89)
34. Crandall's (1946–)
35. Mickies Dairy Bar (1946–)
36. Esquire Club (1947–)
37. Shamrock Bar (1947–)
38. Dolly's Fine Foods (1948–81)
39. Amato's Holiday House (1948–90)
40. The Edgewater Hotel (1948–)
41. Avenue Bar (1950)
42. Paisan's (1950–)
43. Smoky's Club (1953–)
44. Lombardino's (1954–)
45. Nibble Nook (1955–78)
46. Murphy's Nob Hill (1955–86)
47. Cathay House (1955–97)
48. McDonald's (1957–)
49. Nick's Restaurant (1959–)
50. Kelly's Drive-In (1961–81)
51. Ella's Deli (1963–)
52. Gino's (1963–)
53. Josie's (1964–2004)
54. Bud's House of Sandwiches (1966–83)
55. Mariner's Inn (1966–)
56. The Curve (1967–)
57. Paco's (1968–87)
58. Brat und Brau (1969–2014)
59. Ovens of Brittany (1972–2000)
60. Mildred's Sandwich Shop (1973–2013)
61. Peppino's (1974–2009)
62. Parthenon (1974–)
63. Rocky Rococo's (1974–)

64. Dotty Dumpling's Dowry (1975–)
65. L'Etoile (1976–)
66. Myles Teddywedgers (1976–)
67. L'Escargot (1977–93)
68. Cafe Palms (1978–96)
69. Ruby Chinese-American (1978–2004)
70. Husnu's (1980–2014)
71. Quivey's Grove (1980–)
72. Purlie's (1981–2000)
73. Casa de Lara (1983–)
74. Essen Haus (1983–)
75. State Street Brats (1983–)
76. Bahn Thai (1984–)
77. Sunprint (1984–)
78. La Brioche (1985–)
79. New Orleans Take-Out (1985–)
80. Himal Chuli (1986–)
81. Michael's Frozen Custard (1986–)
82. Pasqual's (1986–)
83. Smoky Jon's #1 BBQ (1986–)
84. Otto's (1987–)
85. Stella's Bakery (1988–)
86. Radical Rye (1989–2004)
87. Lao Laan Xang (1990–94, 1997–)
88. Blue Marlin (1990–)
89. Harmony Bar (1990–)
90. Monty's Blue Plate Diner (1990–)
91. Fyfe's (1993–2007)
92. The Great Dane (1994–)
93. Glass Nickel Pizza (1997–)
94. Restaurant Magnus (1998–2010)
95. Laredo's (1998–)
96. Bandung (2000–)
97. Lazy Jane's (2000–)
98. Ian's Pizza (2001–)
99. Restaurant Muramoto (2004–)
100. Old Fashioned (2005–)

MADISON MAGAZINE'S BEST OF MADISON

S tarting in 1982, readers of *Madison Magazine* selected top honors in several varying restaurant categories. This is a summation of those choices. Some of the categories went through several name changes, though their most usual or most recent name appears here. (This can lead to odd results. For example, "Chinese" replaced "Asian" so non-Chinese restaurants may appear in that category.) A first-place award was worth seven points, second place was five points and third place was three points (with fourth place as one point sometimes awarded). Averaging positions broke ties within years.

BAKERY

Gold: Lane's
Silver: Ovens of Brittany
Bronze: Scott's Pastry Shoppe
Also mentioned: Greenbush Bakery, La Brioche

UPSCALE

Gold: L'Etoile
Silver: L'Escargot
Bronze: Restaurant Magnus
Also mentioned: Peppino's, Chez Michel, Harvest, The Edgewater

PIZZA

Gold: Glass Nickel Pizza
Silver: Pizza Hut
Bronze: Pizzeria Uno
Also mentioned: Pizza Pit, Ian's Pizza, Rocky Rococo's

BURGER

Gold: Dotty Dumpling's Dowry
Silver: The Nitty Gritty
Bronze: Culver's
Also mentioned: Tony Frank's, Blue Moon Bar & Grill

FISH FRY

Gold: Avenue Bar
Silver: Crandall's
Bronze: Nau-Ti-Gal
Also mentioned: The Stamm House, Quivey's Grove

BRUNCH

Gold: Nau-Ti-Gal
Silver: The Fess Hotel
Bronze: The Great Dane
Also mentioned: The Concourse Hotel/Dayton St. Grill

MEXICAN/SOUTHWESTERN

Gold: Pedro's
Silver: Laredo's
Bronze: Pasqual's
Also mentioned: Chi-Chi's, Casa De Lara, Eldorado Grill

STEAK/STEAKHOUSE

Gold: Smoky's Club
Silver: Tornado Steakhouse
Bronze: Mariner's Inn
Also mentioned: Johnny Delmonico's

APPENDIX II

BREAKFAST

Gold: Perkins
Silver: Original Pancake House
Bronze: Marigold Kitchen
Also mentioned: Ovens of Brittany, Pancake Cafe, Mickies Dairy Bar

CHINESE

Gold: Imperial Garden
Silver: Hong Kong Cafe
Bronze: Chang Jiang
Also mentioned: Ruby Chinese-American, Sa-Bai Thong, Tom's Red Pepper, Bahn Thai, Ginza of Tokyo

DELI

Gold: Ella's Deli
Silver: Gino's
Bronze: Delitalia
Also mentioned: Fraboni's, Upstairs/Downstairs, Jacobson Bros.

PLACE FOR KIDS

Gold: Ella's Deli
Silver: Showbiz Pizza
Bronze: Henry Vilas Zoo
Also mentioned: McDonald's, Rocky Rococo's, Culver's

ICE CREAM/CUSTARD

Gold: Babcock Hall
Silver: Michael's Frozen Custard
Bronze: Culver's
Also mentioned: Chocolate Shoppe Ice Cream

ITALIAN

Gold: Porta Bella
Silver: Lombardino's
Bronze: Tutto Pasta
Also mentioned: Peppino's, Antonio's, Olive Garden, Paisan's, Biaggi's

APPENDIX II

SERVICE

Gold: The Edgewater
Silver: TGI Friday's
Bronze: Pedro's
Also mentioned: Mariner's Inn, L'Escargot, L'Etoile, Top of the Park

COFFEE/COFFEE ROASTER/COFFEEHOUSE

Gold: Victor Allen's
Silver: Ancora
Bronze: Steep & Brew
Also mentioned: Barriques

GREASY SPOON/DINER

Gold: Mickies Dairy Bar
Silver: The Curve
Bronze: Monty's Blue Plate Diner
Also mentioned: Cleveland's, Bev's

DESSERTS

Gold: Ovens of Brittany
Silver: Ella's Deli
Bronze: Sunprint/Sunporch
Also mentioned: Canterbury Booksellers, Michael's Frozen Custard, Peppino's,
 TGI Friday's

LATE NIGHT DINING

Gold: Perkins
Silver: La Bamba
Bronze: Cafe Palms
Also mentioned: Parthenon, Natt Spil

SEAFOOD

Gold: Blue Marlin
Silver: Captain Bill's
Bronze: Ocean Grill
Also mentioned: Red Lobster

APPENDIX II

TAKE OUT/DELIVERY

Gold: Glass Nickel Pizza
Silver: New Orleans Take-Out
Bronze: Crandall's
Also mentioned: Big Mike's Super Subs, Pasqual's, Pizza Hut

LAKE VIEW

Gold: Paisan's
Silver: The Edgewater
Bronze: Sardine

BBQ/RIBS

Gold: Smoky Jon's #1 BBQ
Silver: Fat Jack's
Bronze: Famous Dave's

OUTDOOR DINING

Gold: The Great Dane
Silver: UW Memorial Union Terrace
Bronze: Nau-Ti-Gal
Also mentioned: Paisan's, Jolly Bob's

MEDITERRANEAN/MIDDLE EASTERN

Gold: Mediterranean Café
Silver: La Paella (tie)
Silver: Bunky's (tie)
Also mentioned: Dardanelles, Husnu's

AMBIENCE

Gold: Porta Bella
Silver: Weary Traveler
Bronze: Eno Vino
Also mentioned: L'Etoile, The Edgewater, Restaurant Magnus, Quivey's Grove

JAPANESE/SUSHI

Gold: Ginza of Tokyo
Silver: Takara
Bronze: Restaurant Muramoto
Also mentioned: Sushi Bar Muramoto, Wasabi

THAI

Gold: Sa-Bai Thong
Silver: Bahn Thai
Bronze: Sukho Thai

INDIAN/NEPALESE

Gold: Maharaja
Silver: Swagat
Bronze: Taj Indian
Also mentioned: Himal Chuli, Taste of India

CARIBBEAN

Gold: Jolly Bob's
Silver: Jamerica
Bronze: David's Jamaican

NEW ORLEANS/CAJUN

Gold: Louisianne's Etc.
Silver: New Orleans Take-Out
Bronze: Liliana's

ISTHMUS'S MADISON'S FAVORITES

Starting in 1983, readers of *Isthmus* selected top honors in several varying restaurant categories. This is a summation of those choices. Some of the categories went through several name changes, though their most usual or most recent name appears here. (This can lead to odd results. For example, "Chinese" replaced "Asian" so non-Chinese restaurants may appear in that category.) A first-place award was worth seven points, second place was five points and third place was three points (with fourth place as one point sometimes awarded). Averaging positions broke ties within years.

BBQ/RIBS

1. Smoky Jon's #1 BBQ
2. Fat Jack's
3. Famous Dave's
Runner-up: Purlie's

HAMBURGER

1. Dotty Dumpling's Dowry
2. The Plaza
3. Weary Traveler
Runners-up: The Nitty Gritty, Blue Moon Bar & Grill

APPENDIX III

PIZZA

1. Glass Nickel Pizza
2. Pizzeria Uno
3. Ian's Pizza
Runners-up: Pizza Hut, Paisan's, Roman Candle, Pizza Extreme, Rocky Rococo's

ICE CREAM/FROZEN DESSERT

1. Babcock Hall
2. Michael's Frozen Custard
3. The Chocolate Shoppe Ice Cream

FISH FRY

1. Avenue Bar
2. Crandall's
3. The Stamm House

FOOD CART

1. Buraka
2. Loose Juice
3. Jamerica
Runners-up: Sukho Thai, El Charro

CHINESE

1. Imperial Garden
2. Hong Kong Café
3. Bahn Thai

FINE DINING/WHEN SOMEONE ELSE PAYS

1. L'Etoile
2. L'Escargot
3. Blue Marlin
Runner-up: Restaurant Magnus

MEXICAN

1. Pasqual's
2. La Hacienda
3. Laredo's

Runners-up: Pedro's, Casa De Lara, El Charro, Taqueria Guadalajara, Chi-Chi's

DESSERTS

1. Ovens of Brittany
2. Ella's Deli
3. Monty's Blue Plate Diner

Runners-up: Michael's Frozen Custard, Sunprint, Hubbard Avenue Diner, Bluephies

"OTHER" ETHNIC CUISINE

1. Himal Chuli
2. LuLu's
3. Lao Laan-Xang

Runners-up: Bahn Thai, Saigon-Noodles, Bandung, Husnu's, Mt. Everest, Parthenon, Kosta's on State, Vientiane Palace, The Green Owl Cafe

DELI/DELI COUNTER

1. Ella's Deli
2. Fraboni's
3. Upstairs/Downstairs

Runners-up: Willy Street Co-Op, Jacobson Bros.

BRUNCH

1. The Fess Hotel
2. Nau-Ti-Gal
3. The Concourse Hotel

Runners-up: White Horse Inn, Ovens of Brittany, Sardine

APPENDIX III

VEGETARIAN FARE

1. Himal Chuli
2. Monty's Blue Plate Diner
3. Savory Thymes
Runners-up: Sunprint, Country Life, Sunporch, Lao Laan-Xang, The Green Owl Cafe, Peacemeal, Harmony Bar

ITALIAN

1. Porta Bella
2. Lombardino's
3. Paisan's
Runners-up: Tutto Pasta, Pasta Per Tutti, Gino's

BREAKFAST

1. Original Pancake House
2. Marigold Kitchen
3. Lazy Jane's
Runners-up: Mickies Dairy Bar, Monty's Blue Plate Diner, Cleveland's

COFFEE

1. Victor Allen's
2. Mother Fool's
3. Steep & Brew
Runners-up: Ancora, Barriques, Just Coffee

CHEAP EATS

1. Taco Bell
2. McDonald's
3. UW Memorial Union
Runners-up: Mediterranean Café, Noodles & Co., Henry Vilas Zoo, Porto Bananas

STEAK

1. Smoky's Club
2. Tornado Steakhouse
3. Prime Quarter
Runner-up: Johnny Delmonico's

BAKERY

1. Lane's
2. La Brioche
3. Ovens of Brittany
4. Greenbush Bakery
Runners-up: Batch Bakehouse, Clasen's, Madison Sourdough, Breadsmith

LATE NIGHT EATS

1. Cafe Palms
2. Perkins
3. Weary Traveler
Runners-up: Parthenon, La Hacienda, Taco Bell, The Great Dane, Ian's Pizza

SOUTHEAST ASIAN/THAI

1. Sa-Bai Thong
2. Bahn Thai
3. Lao Laan-Xang
Runners-up: Ha Long Bay, Vientiane Palace

MIDDLE EASTERN/MEDITERRANEAN

1. LuLu's
2. Mediterranean Café
3. Kabul
Runners-up: Husnu's, The Casbah, Dardanelles

INDIAN

1. Maharaja
2. Maharani
3. Taj Indian

JAPANESE/SUSHI

1. Takara
2. Wasabi
3. Sushi Bar Muramoto
Runners-up: Restaurant Muramoto, Ginza of Tokyo

BEST NEW RESTAURANT
(*MADISON MAGAZINE / ISTHMUS*)

This is a compilation of the voting in the Best New Restaurant category each year. *Isthmus* did not begin this category consistently until 1994 (running once in 1987 and again 1990 to 1992) and *Madison Magazine*, for some reason, made editorial choices in 2010 instead of running a category.

1985
MADISON MAGAZINE
Ciatti's
Ovens of Brittany (East)
Bahn Thai

1986
MADISON MAGAZINE
Kosta's On State
Francie's Casual Cafe
Porto Bananas

1987
MADISON MAGAZINE
Antonio's
Land of the Lost
Alexander's

ISTHMUS
Wilson Street Grill
Land of the Lost
El Sombrero

1988
MADISON MAGAZINE
Wilson Street Grill
Sergio's Mexican
Edwardo's Natural Pizza

1989
MADISON MAGAZINE
Ruby Tuesday
Da' Cajun Way
Rhode's Grill

1990
MADISON MAGAZINE
Chili's
Rio's
Emerald Isle

ISTHMUS
Blue Marlin
Kabul

1991
MADISON MAGAZINE
Blue Marlin
Wild Iris Cafe
La Provenzale

ISTHMUS
Wild Iris Cafe
Botticelli's
La Bamba

1992
MADISON MAGAZINE
Saz
Olive Garden
Botticelli's

ISTHMUS
Olive Garden
Savory Thymes
Tanyeri Grill

1993
MADISON MAGAZINE
Applebee's
Jolly Bob's
The Dry Bean

1994
MADISON MAGAZINE
Deb & Lola's
Sunprint (West)
Pasta Per Tutti

ISTHMUS
Deb and Lola's
Grapevine

1995
MADISON MAGAZINE
Coyote Capers
La Paella
Kafe Kahoutek

ISTHMUS
Coyote Capers
Kafe Kahoutek

1996
MADISON MAGAZINE
Waterfront 131
Granita
Old Chicago

Isthmus
Mad City Cafe
Sol Caribe
JT Whitney's

1997
Madison Magazine
The Opera House
Dardanelles
Cornerstone

Isthmus
Mediterranean Café
La Hacienda
The Opera House

1998
Madison Magazine
Outback Steakhouse
Restaurant Magnus
Famous Dave's
Luigi's

Isthmus
Tutto Pasta
Restaurant Magnus
Luigi's

1999
Madison Magazine
Cafe Continental
Restaurant Magnus
Eldorado Grill
Outback Steakhouse

Isthmus
Madison Marsala
Oceans Brasserie
Eldorado Grill
State Bar & Grill

2000
Madison Magazine
Clay Market Cafe
Nadia's
Hubbard Avenue Diner

Isthmus
Clay Market Cafe
Bandung
Great Taste Chinese

2001
Madison Magazine
Biaggi's
Harvest
Spices Kitchen

Isthmus
Biaggi's
Lazy Jane's
Harvest

2002
Madison Magazine
Johnny Delmonico's
Panera
Marigold Kitchen

APPENDIX IV

ISTHMUS

Weary Traveler
Margiold Kitchen
Peacemeal

2003
MADISON MAGAZINE

Pancake Cafe
Ocean Grill
Benvenuto's

ISTHMUS

Hawk's
Curry N Hurry
Ocean Grill
Benvenuto's

2004
MADISON MAGAZINE

Fitch's Chophouse
Griglia Tuscany
RodeSide Grill

ISTHMUS

Restaurant Muramoto
Bunky's
Natt Spil
Yirgalem

2005
MADISON MAGAZINE

Eno Vino
Fitch's Chophouse
Restaurant Muramoto

ISTHMUS

Roman Candle Pizzeria
Brocach Bar & Grill
Eno Vino

2006
MADISON MAGAZINE

Old Fashioned
Roman Candle Pizzeria
Johnny's Italian Steakhouse

ISTHMUS

Tex Tubb's Taco Palace
Old Fashioned
Dobhan

2007
MADISON MAGAZINE

Sardine
Cloud 9 Grille
The Melting Pot

ISTHMUS

Sardine
Inka Heritage
Burrito Drive

2008
MADISON MAGAZINE

Sucre
Liliana's
Samba Brazilian Steakhouse

ISTHMUS
Samba Brazilian Steakhouse
Liliana's
Sala Thai
Alchemy

2009
MADISON MAGAZINE
Good Times Restaurant & Games
La Brioche True Food
1855 Saloon & Grill

ISTHMUS
Daisy Cafe & Cupcakery
The Bayou
La Brioche True Food

2010
ISTHMUS
The Green Owl Cafe
The Coopers Tavern
Ha Long Bay

2011
MADISON MAGAZINE
The Coopers Tavern
Dahmen's Pizza Place
The Vintage Brewing Co.

ISTHMUS
Graze
Underground Kitchen
Umami Ramen & Dumpling Bar

2012
MADISON MAGAZINE
Merchant
Buck & Honey's
Umami Ramen & Dumpling Bar

ISTHMUS
A Pig in a Fur Coat
Salvatore's Tomato Pies
Banzo (Cart)
Tempest Oyster Bar

2013
MADISON MAGAZINE
DLUX
A Pig in a Fur Coat
Forequarter

ISTHMUS
Forequarter
DLUX
Banzo (Restaurant)

2014
MADISON MAGAZINE
Grampa's Pizzeria
Heritage Tavern
La Taguara

ISTHMUS
Heritage Tavern
Grampa's Pizzeria
Short Stack Eatery

2015
MADISON MAGAZINE
OSS Madison
Cento
Bassett Street Brunch Club

BIBLIOGRAPHY

Throughout these references, the following abbreviations are used:
CT = *Capital Times*
WSJ = *Wisconsin State Journal*

The following sources are used throughout the book:
East Side History Club. *An East Side Album: A Community Remembers*. Edited by Sarah White. Madison, WI: Goodman Community Center, 2008.
Guthrie, Margaret E. *Best Recipes of Wisconsin Inns and Restaurants*. Amherst, WI: Amherst Press, 1986.
Hoekstra, Dave. *The Supper Club Book: A Celebration of a Midwest Tradition*. 1st ed. Chicago: Chicago Review Press, 2013.
Levitan, Stuart D. *Madison: The Illustrated Sesquicentennial History*. Madison: University of Wisconsin Press, 2006.
Mollenhoff, David V. *Madison, a History of the Formative Years*. Dubuque, IA: Kendall/Hunt, 1982.
R.L. Polk & Co. and Wright Directory Co. *Madison (Dane County, Wis.) City Directory*. Kansas City, MO: R.L. Polk, 1846–2014.
Tipler, Gary. *Williamson Street: A Historical Survey and Walking Tour Guide*. Madison, WI: Landmarks Commission, 1978.
WORT–Madison: 25 Years of Community Radio. Madison, WI: Mica Press, 2000.
WSJ. "Employees to Picket 55 Restaurants." June 20, 1937.

BIBLIOGRAPHY

CHAPTER 1

Balousek, Marv. "Fire Destroys Five Businesses." *WSJ*, January 9, 1982.

Beck, Marianna. "Lysistrata—Madison's First Feminist Restaurant." *CT*, April 7, 1978.

Bertagnoli, Lisa. "Ovens of Brittany Prepares to Expand: Five-Unit Concept Tries to Consolidate Purchasing, Marketing and Finances." *Restaurants and Institutions*, September 1998.

Browe, Calmer. "Closing of Last '1 Minute Lunch' Ends Eddy's 29 Years as Caterer." *CT*, February 15, 1928.

Capital City Courage: A History of the Madison Fire Department 1856–1991. Madison, WI: MFD History Book Committee, 1992.

Clark, Kevin. "Restaurant Business Overview: Slow but Steady." *In Business*, October 1982.

CT. "Chas. Cuccia Gets 1–5 Years, May Get Probation for Setting Restaurant Fire." October 7, 1931.

———. "Elizabeth Russ Dies at Age 88." April 5, 1960.

———. "$100,000 Parthenon Blaze Called Deliberate." February 20, 1979.

———. "Youth, near Death, Admits Arson." July 22, 1931.

Dieckmann, June. "Arsonists Strike Four Buildings Causing $21,500 in Damages." *WSJ*, February 19, 1976.

———. "$500,000 Fire Hits Block on Square." *WSJ*, December 6, 1946.

Durand, Janice. *Getting the Most Out of Madison: A Guide.* Madison, WI: Puzzlebox Press, 1974.

Exploring the Dudgeon-Monroe Neighborhood. Madison, WI: Dudgeon-Monroe Neighborhood Association, 1999.

Holveck, Timothy. *Hotel Washington: A Memoir.* Madison, WI: Timothy Holveck, 2001.

"How America Spends: Food & Drink Spending by City." *bundle.com*, 2010. https://grist.files.wordpress.com/2010/08/bundle_foodanddrink.jpg.

Judd, Joan. "A Scrutable Guide to Madison's Chinese Restaurants: Several Years Ago There Was Only One." *Madison Magazine*, February 1980.

"Lysistrata: A Feminist Dream Up in Flames." *Feminist Connection*, January 1982.

Madison's LGBT Community: Hotel Washington and Lysistrata. UW–Madison's Campus Voices, 2012. http://youtu.be/aU-CpCnUbkw.

Murray, Catherine Tripalin. *Spaghetti Corners and All That...Sauce!* 1st ed. Madison, WI: Greenbush...remembered, 2011.

Noll, Henry. "Sunday Thoughts." *WSJ*, June 27, 1943.

Van Eyck, Masarah. "State Street's Global Legacy." *Madison Magazine*, April 2005.

WSJ. "Cuccia Fined $750 on Arson Charge Change." October 6, 1931.

———. "Noted Chinese Restaurateur Nom Yee Dies." January 9, 1984.

————. "Rebuilding Historic Inn: New St. Nicholas Could Tell Much of the Story of Madison." June 16, 1910.

Wyngaard, John. "Politicians, Newsman Mourn Closing of Simon House." *WSJ*, January 29, 1971.

CHAPTER 2

Barbour, Clay, and Mary Spicuzza. "Cameras? No. Guns? Sure!" *WSJ*, October 29, 2011.

Capellaro, Catherine. "Just Dining Restaurant Guide Returns to Help Steer Madison Diners to Better Workplaces." *Isthmus*, December 13, 2013.

Carr-Elsing, Debra. "Farmers' Market by the Numbers." *CT*, April 19, 2007.

————. "In Charge of Farmers' Market." *CT*, March 26, 2001.

Cook, Diana. *Wisconsin Capitol: Fascinating Facts.* 1st ed. Madison, WI: Prairie Oak Press, 1991.

Hesselberg, George. "Farmers' Market Losing Part of Its Roots." *WSJ*, March 14, 1984.

Jordan, Pete. *Dishwasher: One Man's Quest to Wash Dishes in All Fifty States.* New York: Harper Perennial, 2007.

Josephson, Matthew. *Union House, Union Bar: The History of the Hotel and Restaurant Employees and Bartenders International Union AFL-CIO.* New York: Random House, 1956.

Just Dining : A Guide to Restaurant Employment Standards in Downtown Madison. 1st–3rd eds. Madison, WI: Workers' Rights Center, 2012–2014.

Katz, Nikki. "Sunday Service: Volunteers Unite for Savory Sunday, a Program That Provides Meals for the Homeless in Downtown Madison." *WSJ*, December 3, 2006.

Martell, Chris. "Tasting Event Was Adventure." *WSJ*, September 23, 1990.

Schneider, Pat. "'Glean' Sweep." *CT*, September 10, 2008.

Troller, Susan. "From Farm to Table: Farmers' Market Produce on the Menu in Chicago Hotspots." *CT*, April 16, 2009.

Ullman, Owen. "Farmers' Mart Booms." *WSJ*, October 1, 1972.

White, Sarah E. *Madison Women Remember: Growing up in Wisconsin's Capital.* Charleston, SC: Arcadia, 2006.

WSJ. "Breakfast Brigade is Routed in Capitol." March 9, 1938.

————. "Capitol Cafe to Open January 10." January 2, 1917.

————. "Capitol Kept Here by Park Hotel Drive." December 13, 1938.

————. "Winter Market to Debut in November." September 24, 2001.

BIBLIOGRAPHY

CHAPTER 3

Beckmann, Ann. "New Restaurant Looks Expensive but Its Charm Is Deceiving." *WSJ*, May 5, 1973.

Beck, Marianna. "Food for Thought: Restaurateurs Explain What Makes/Breaks Their Business." *In Business*, January 1982.

Campbell, Genie. "La Ferme Cuisine Doesn't Match High Prices." *WSJ*, November 2, 1980.

———. "Otto's Restaurant Owners Have Reason for Optimism." *WSJ*, July 26, 1987.

Davis-Humphrey, Valeria. "A Piece of the Past." *WSJ*, December 23, 2002.

Getto, Dennis. "Food, History Blend Nicely." *Milwaukee Journal*, November 23, 1992.

———. *Great Wisconsin Restaurants: 101 Fabulous Choices by the* Milwaukee Journal Sentinel*'s Restaurant Critic*. Madison, WI: Wisconsin Trails, 1997.

Gould, Whitney. "Quivey's Grove Offers Taste of the Past." *CT*, May 23, 1980.

Guthrie, Margaret E. *The Best Midwest Restaurant Cooking*. Ames: Iowa State University Press, 1989.

———. *Quivey's Grove Heritage Cookbook*. 1ˢᵗ ed. Madison, WI: Prairie Oak Press, 1994.

Kovalic, John. "West Side Pizzeria Uno Keeps High Standard." *WSJ*, August 4, 1991.

Martell, Chris. "Fyfe's Offers Outstanding Pasta Dishes, at a Price." *WSJ*, November 14, 1993.

———. "Otto's Takes on Middle Eastern Flavor." *WSJ*, September 1, 1996.

———. "That's Entertaining: The Gospel, According to Martha Stewart." *WSJ*, September 21, 1989.

———. "3 Restaurants Specialize in Creole." *WSJ*, June 2, 1985.

Muckian, Michael. "Creative, Hopped-Up Dinner at Quivey's a Bargain at $30." *CT*, February 25, 1995.

Mulhern, Barbara. "City Yanks House of Hunan Restaurant License." *CT*, August 5, 1986.

Rybarczyk, Tom. "Garton's Stubbornness Saved Ten Chimneys." *Milwaukee Journal-Sentinel*, August 3, 2003.

Schubert, Sunny. "This Campfire Cook a Real Pro." *WSJ*, May 31, 1981.

Strohs, Warsaw, Denice Williams and Walter Shorty (pseudonyms). *Beer Drinking in Madison: A Complete Guide to Madison Taverns*. Madison, WI: Warsaw Strohs, 1983.

Troller, Susan. "A Restaurant's Mood Sets the Stage for Food." *CT*, February 5, 2009.

———. "25 Years of Memories: Rustic Restaurant Is Realization of Founder's Vision." *CT*, June 30, 2005.

BIBLIOGRAPHY

Zaleski, Rob. "Feeding Frenzy: State Still Hooked on Friday Night Fish Fries." *CT*, August 9, 2007.

CHAPTER 4

Beckmann, Ann. "Brunch Becomes a Local Sunday Habit." *CT*, June 11, 1977.

Benedict, Leonore. "Home Is a Happy Hotel." *Madison Select*, May 1971.

Brayton, A.M. "The Rambler." *WSJ*, July 9, 1933.

Brixey, Elizabeth. "The Manor Is Tasty Stop for Lunch." *WSJ*, December 3, 1989.

Campbell, Genie. "Readers' Favorite Fish Spots." *WSJ*, August 30, 1981.

Christians, Lindsay. "Thanksgiving with the Pros: Local Chefs Share Their Holiday Traditions." *77 Square*, November 17, 2011.

Collins, Margaret. "New Kennedy Manor Gets off to a Great Start." *CT*, September 4, 1993.

Cook, Marvin. "Lynch Tells Aide: No Dishpan Hands." *CT*, February 2, 1974.

CT. "Fess Family Had Headed Hotel More than Century." March 9, 1960.

———. "Re-Open Cafe at Historic Simon." December 6, 1952

———. "Simon House Honored Again." September 29, 1959.

———. "Student Housing Trend Changes Here." November 1, 1929.

Custer, Frank. "Century-Old Fess Hotel Here Is Undergoing Face-Lift Project." *CT*, November 26, 1974.

Daniels, Mrs. Tom. "Pheasant Branch Will Observe 100th Anniversary of Stamm House." *WSJ*, September 21, 1947.

Darlington, Tenaya. "There's No Biz Like Dough Biz: Madison Sourdough May Have Closed, but Owners Take on New Roles." *Isthmus*, July 14, 2000.

Davidoff, Judith. "Diner Redux: Cleveland's Makes a Comeback of Sorts." *Isthmus*, February 17, 1995.

Gordon, Lorena. *Middleton's Early Years: The People and Businesses Important to Middleton's Growth.* 3rd ed. Middleton, WI: Printing Place, 2006.

Gruber, Holly. "Stamm House Ambience Appealing." *CT*, February 20, 1985.

Harding, Cathryn. "Their Moveable Feat: Craig and Christy Reclaim Another Downtown Restaurant Space." *Isthmus*, April 9, 1993.

Haug, John. "Lunch at Cleveland's Won't Be Quite the Same." *CT*, August 25, 1971.

Hunter, John Patrick. "Simon House Art 'Gallery' Now Numbers Nearly 200 Paintings." *CT*, May 26, 1959.

Ivey, Mike. "Fess Sold, to Be Replaced by Brew Pub." *CT*, April 20, 1994.

Judd, Joan. "Cleveland's: A Popular Spot for 64 Years." *WSJ*, August 30, 1970.

———. "Pilots Steer Way into New Career." *WSJ*, November 15, 1974.

———. "Sunday Brunchers Have Lots of Choices." *Window*, March 28, 1978.

Kadushin, Raphael. "A City Classic: The Urbane Kennedy Manor Offers Polished Cuisine." *Isthmus*, March 5, 1999.

Kaufman, Diana. "Hot Meal, Good Deal." *CT*, February 18, 1989.

Kubly, Herbert. "Dining Amidst History." *Milwaukee Journal*, January 30, 1977.

Martell, Chris. "Kennedy Manor Perfects Art of Dining." *WSJ*, February 27, 2000.

———. "Return to Elegance: Kennedy Manor to Revive Genteel Atmosphere." *WSJ*, August 25, 1993.

Miller, Mike. "Going out in Style." *CT*, June 17, 1994.

Miller, Nicole. "Is Madison's Plate of Restaurants Too Full?" *CT*, October 14, 1994.

Mills, Marion. "She's a Pro at Cooking for a Crowd." *WSJ*, August 28, 1977.

Minnich, Jerry. "Back to the Garden." *Isthmus*, August 23, 1991.

———. "The Classic Cafes: What Are They? Where Are They? And Why Are They Still Around?" *Isthmus*, February 13, 1987.

———. *Eating Well in Wisconsin*. 2nd ed. Black Earth, WI: Prairie Oak Press, 2003.

———. "Square Meals: How to Get Good, Fast Food around the Capitol." *Isthmus*, December 4, 1987.

Noll, Henry. "Old Dining Rooms Gone, but Many Relish Simon Hotel Meals in Memory." *WSJ*, February 1, 1948.

Pfefferkorn, Robert. "Simon House to Become Offices." *WSJ*, January 29, 1977.

Riddle, Jennifer. "Cleveland's Lunch Room Is Closing." *WSJ*, September 25, 1992.

Schlatter, Janet M. "German Bakers Bring Gourmet Touch to New Pastry Shop." *CT*, April 25. 1962.

Schmidt, Mary Jo. "Best Item Isn't on the Menu Down at Cleveland's Lunch." *WSJ*, January 7, 1982.

Schubert, Sunny. "Fess Is Still Delightful, Delectable." *WSJ*, February 14, 1982.

Sebastian, Jerry. "Orchids for Blooming Middleton Firms." *WSJ*, March 23, 1994.

Sorensen, Sterling. "Adams and Combs Lease Simon Hotel; Remodel Historic Cafe." *CT*, August 15, 1952.

Vuynovich Kovach, Vesna. "It's Greek to Her: Beth Fatsis of Atlantis Taverna." December 1, 2008. http://vesnaswriting.blogspot.com/2008/12/its-greek-to-her-beth-fatsis-of.html.

Wendling, Patrice. "Cleveland's Makes Comeback." *CT*, February 15, 1995.

Whiffen, Lorna. "Step into the Past at Fess Hotel Bars." *CT*, November 10, 1975.

WSJ. "H.F. Guernsey Dies Suddenly: Official Has Stroke at Union Meeting." November 10, 1942.

BIBLIOGRAPHY

———. "Restaurants Defy Strike, Two Reopen." June 23, 1937.

———. "Three Nabbed in 'Ball' Raids: Cafe Owners to Get Jury Trials." June 6, 1935.

———. "Traditions of Elegance Kept in 'Anthony's Simon House.'" March 11, 1971.

CHAPTER 5

"African, African American, Latino, Southeast Asian, American Indian Business Directory." *Madison Times*, 2000.

Anana, Milele Chicasa. "Who We Are: A Very Brief History of the African American Community's Contributions to Madison." *Madison Magazine*, April 2006.

Beck, Joe. "Purlie's Brings Soul Food to Madison." *WSJ*, March 21, 1982.

Black Book. Madison, WI: National Association for the Advancement of Colored People Madison Branch, 1972.

"Case Study of Integrated Housing and Property Values." Madison, WI: Governor's Commission on Human Rights, 1957.

"Greater Madison Black Business Directory." Madison, WI: Umoja, 1992.

Gulley, Carson. *Seasoning Secrets: Herbs and Spices*. Madison, WI: Strauss Printing Co., 1949.

———. *Seasoning Secrets and Favorite Recipes of Carson Gulley*. Madison, WI: Strauss Printing Co., 1956.

Halverson, Donald L. Interview with Barry Teicher for UW–Madison Archives Oral History Interviews. #364. 1983.

Hargrove, Denise. "A Sense of Community." Interview with Theo Kramer. *Feminist Voices*, February 1991.

Harris, Richard. *Growing Up Black in South Madison: Economic Disenfranchisement of Black Madison*. Madison, WI: RoyTek, 2012.

Maraniss, Elliott. "Refusal to Transfer License Shakes His Faith in City." *CT*, July 25, 1960.

Martell, Chris. "A Place in Black History." *WSJ*, February 5, 2006.

Mattern, Carolyn J. "Crestwood: A Pioneer Cooperative Housing Project." *Historic Madison: A Journal of the Four Lake Region* 14 (1997).

"Maxine Trotter." *Umoja*, March 1997.

Murphy, Chris. "Black Leader 'Gone and It Hurts.'" *CT*, June 2, 1998.

Schneider, Pat. "'Celebrating Black Madison': Benefit Will Focus on Business History." *CT*, March 20, 2003.

Shade, Barbara Robinson. "Chef Carson Gulley Made Culinary History at UW." *CT*, May 23, 1979.

Stone, Michael. "Rowdiness Could Force Closing of Purlie's." *CT*, December 15, 1990.

BIBLIOGRAPHY

WSJ. "Three Feminine Nimrods Obtain Required Papers." September 17, 1916.

Zmudzinski, Florence. "Leaving Greenbush: The Triangle Relocation Supervisor Looks Back on Urban Renewal, Public Housing, and Equal Opportunity." *Historic Madison: A Journal of the Four Lake Region* 20 (2005).

Chapter 6

Bordsen, John. "D. Jeff Stanley and His Crusade against Bum Burgers." *CT*, April 20, 1978.

Campbell, Genie. "Dotty Dowry's Hamburgers among the Best in Town." *WSJ*, September 21, 1980.

Carr-Elsing, Debra. "The Pie Queen." *CT*, January 8, 1992.

CT. "Dotty's Gives Up, Accepts." June 17, 1977.

———. "Operator of Red and White Hamburger Shop to Retire." December 14, 1965.

Custer, Frank. "Fifty Years Haven't Changed Good Red and White Burgers." *CT*, November 24, 1976.

———. "'Real Mayor' of Henry Street Still Going as Strong as Ever." *CT*, May 13, 1971.

Davidoff, Judith. "Homer V. Simpson Gets Honorary Street Sign in Madison." *Isthmus*, November 19, 2014.

Gaskill, Warren. "Dotty Dumpling Moving Dowry Downtown." *CT*, April 23, 1991.

Haines, Dorothy Brown. *Monona in the Making: History of the City of Pride, 1938–1975*. Monona, WI: Historic Blooming Grove Historical Society, 1999.

Kalk, Samara (as Samara Kalk Derby). "Burgers Galore, and a Bounty of Food in Verona." *CT/WSJ*, November 25, 2004.

———. "Get Some Burritos to Open off State Street." *CT*, September 12, 2013.

Kepecs, Susan. "Table Talk: Dean Hetue." *Isthmus*, August 27, 2004.

Lynch, Kevin. "Arrogant Domain." *CT*, May 1, 1999.

Mertes, Chris. "Nitty Gritty Celebrating Two Months in Historic Cannery." *Sun Prairie Star*, January 25, 2014.

Milverstedt, Fred. "Remembering Marsh Shapiro." *Isthmus*, December 28, 2012.

Minnich, Jerry. "Meat City: The Madison Tavern Burger: A Special Report." *Isthmus*, March 3, 1989.

Mitchard, Jacquelyn. "Burgers: An Enduring American Tradition." *CT*, July 28, 1982.

Moe, Doug. "At Last, a Real Chicago Hot Dog Returns." *CT*, November 6, 2007.

———. "One Tony Frank's Will Be Jimmy's." *CT*, August 21, 1997.

Murray, Catherine Tripalin (as Catherine Murray). "Monona Drive-in Flavored History." *WSJ*, October 12, 1994.

———."Nibble Nook Memories Live on in Culinary Family." *WSJ*, April 18, 2004.

Opoien, Jessie. "The Sauce Remains the Same: The Plaza Converted into 'Eco-Dive.'" *CT*, April 13, 2014.

Rath, Jay. "Keeping Plaza in the 'Family.'" *CT*, January 20, 2003.

———. "New Mickie's Dairy Bar Better than What Once Was." *CT*, November 30, 1991.

———. "Plaza Tavern's Plazaburger Adds Taste of History." *CT*, July 21, 1990.

Waidelich, Ann. "Madison's Lunch Wagons and Diners." *Historic Madison: A Journal of the Four Lake Region* 21 (2008).

WSJ. "$13,200 Awarded for Nibble Nook." November 30, 1962.

———. "Tony Frank, 63, West Side Tavern Operator, Dies." February 27, 1962.

Zewlewsky, Paul. "Plaza Has Own Secret to Success." *CT*, January 18, 1989.

CHAPTER 7

Allen, Terese. *The Ovens of Brittany Cookbook*. 1ˢᵗ ed. Amherst, WI: Amherst Press, 1991.

Bertagnoli, Lisa. "Ovens of Brittany Prepares to Expand: Five-Unit Concept Tries to Consolidate Purchasing, Marketing and Finances." *Restaurants and Institutions*, September 1998.

Carr-Elsing, Debra. "Monroe Ovens Goes All Scratch." *CT*, October 13, 1993.

———. "Ovens: Recipes and Reminiscences." *CT*, June 5, 1991.

Church, Charles F. *Wisconsin Quantity Cuisine: The Foods That Make Wisconsin Famous*. Boston: Cahners Books International, 1976.

CT. "Bank's Action Closes the Ovens of Brittany." December 12, 1974.

Curd, Dan. "Top of the Food Chain." *Madison Magazine*, December 2004.

Daniell, Constance. "Star Above." *Milwaukee Journal*, February 7, 1988.

Davidoff, Judith. "Bartender, Make That a Double: The Buzz Serves up Coffee Cocktails with an Attitude." *Isthmus*, November 13, 1998.

———. "The Epilogue: Botticelli's Closes, and the Space Is up for Rent." *Isthmus*, December 19, 1997.

———. "Whatever Happened to Jo Anna Guthrie?" *Isthmus*, February 11, 2000.

Gaskill, Warren. "Ovens Ventures Over to the East Side." *CT*, October 24, 1984.

Gold, Jonathan. "A Woman of Sustenance." *Gourmet*, October 2001.

Gribble, Roger A. "Ovens of Brittany to Close Restaurant: State Street Business Lasted 23 Years." *WSJ*, October 18, 1995.

BIBLIOGRAPHY

Griffin, Tom. "Baking Tempting Treats: Pastry Chef Says We like Them Rich, Gooey." *Madison Press Connection*, March 29, 1978.

Harding, Cathryn. "Another Course." *Isthmus*, March 12, 1993.

Hatchen, Harva. "Restaurant Is Success Before It's Officially Open." *Milwaukee Journal*, June 28, 1972.

Ivey, Mike. "Fordem Ovens Shut as State Site Struggles." *CT*, August 23, 1994.

Johnson, Paul. "Ovens Shuts Restaurant." *WSJ*, August 27, 1994.

Judd, Joan. "Ovens of Brittany Add a French Touch." *WSJ*, January 20, 1974.

Kadushin, Raphael. "Cheap Chow: Best Bets for Campus Dining on a Budget." *Isthmus*, August 30, 2002.

———. "Lady Bountiful." *Madison Magazine*, September 1999.

Kalk, Samara (as Samara Kalk Derby). "Downtown's Culinary Boost Highlights 2005." *CT/WSJ*, December 29, 2005.

———. "New Owners Hope to Bring Ovens Back to Life." *CT*, June 28, 2001.

Kirkwood, Judith. "Mother Ovens." *Madison Magazine*, March 1996.

Kubly, Herbert. "A Galaxy of Spice." *Milwaukee Journal*, December 12, 1976.

———. "Ovens of Brittany." *Milwaukee Journal*, March 4, 1973.

Mable, Nathan. "Drinks on Him: The Man Behind Barriques." *Middleton Times-Tribune*, December 24, 2012.

Martell, Chris. "Odessa's Journey." *WSJ*, April 20, 2003.

Minnich, Jerry. "Carryout with Class." *Isthmus*, July 14, 1989.

———. "Gee, Beav, a New Ovens." *Isthmus*, November 3, 1989.

———. "Return to Camelot: The New Menu at Ovens East Is One of the Best." *Isthmus*, January 22, 1993.

———. "The Shock of the New: A Food Critic Adjusts to Madison's Nouvelle Cuisine." *Isthmus*, August 14, 1987.

Moe, Doug. "Celebrating 20 Years of Meals at Monty's." *WSJ*, July 14, 2010.

Muckian, Michael. "Restaurant Critic Presents 1996 Cornucopia Awards." *CT*, December 28, 1996.

Newman, Judy. "Home-Grown Restaurants Are Booming." October 30, 1994.

Piper, Odessa. "Fresh Out of the Ovens." *Madison Magazine*, November 2014.

Ramde, Dinesh. "Chef and His Sister Will Buy L'Etoile." *WSJ*, March 12, 2005.

Schubert, Sunny. "L'Etoile Returns to Good Old Days." *WSJ*, November 22, 1981.

Schuetz, Lisa. "Last Ovens of Brittany to Close: Its Lease Isn't Being Extended." *WSJ*, December 15, 2000.

Strainchamps, Anne. "The Pied Piper." *Isthmus*, October 25, 1996.

Wolff, Barbara. "Manifest Destiny: The Croissant Empire Goes West." *Isthmus*, January 16, 1981.

WSJ. "Andrea's Restaurant Closes Doors Without Explanation." July 8, 1976.

Zaleski, Rob. "By Helping Tibetans, Ovens Goes with Its Flow." *CT*, December 27, 1991.

BIBLIOGRAPHY

Chapter 8

Balousek, Marv. "Mickies Isn't Going Anywhere." *WSJ*, April 13, 2006.
Campbell, Genie. "Humor Spices Mexican Fare." *WSJ*, August 17, 1986.
———. "Mickie's Follows a Great Tradition." *WSJ*, September 7, 1980.
Cosgrove, Howard. "New Shop Feeds Body and Soul." *CT*, September 27, 1976.
CT. "Old Connection, New Space." February 4, 1992.
Gribble, Roger A. "Changes Are Cooking." *WSJ*, February 13, 1994.
———. "Gelman Sees Bright Future for Business." *WSJ*, July 21, 1994.
Ivey, Mike. "No Dinner Drinks: City Balks at Outdoor Libations at New Brazilian Grill." *CT*, August 21, 2007.
Johnson, Robb. "Mickies: A Badger Beanery." *CT*, November 9, 1973.
Kades, Deborah. "Moen Creek." *WSJ*, March 9, 1994.
Kalk, Samara. "Sunprint by Another Name Is Still Good." *CT*, April 5, 1997.
Kendrick, Rosemary. "Tiny Market Grows with Help from Neighbors." *CT*, March 31, 1982.
Minnich, Jerry. "Square Meals: How to Get Good, Fast Food around the Capitol." *Isthmus*, December 4, 1987.
Muckian, Michael. "Sunporch Good but Not Great." *CT*, May 24, 1997.
———. "Sunporch Menu, Ambience Still Brighten Up Day." *CT*, July 15, 2000.
Prager, Karen. "Sunprint Cafe Offers Fast Food, Sinful Desserts." *CT*, December 9, 1987.
Rath, Jay. "New Mickie's Dairy Bar Better Than What Once Was." *CT*, November 30, 1991.
Smith, Susan Lampert. "Sunprint Grows Up into Fine Restaurant." *WSJ*, August 9, 1992.
Tish, Jason L. "Landmarks and Landmark Sites Nomination Form: Woman's Building." 2004. http://www.cityofmadison.com/planning/landmark/nominations/164_24WGilmanSt.pdf.
Treleven, Ed. "Business Owners Will Plead Guilty to Tax Evasion." *WSJ*, August 14, 2009.
WSJ. "Andrew Weidemann Dies in California." August 5, 1972.

Chapter 9

Barclay, Kimberly. "Bellini Italian Restaurant: A Restaurant and Family with Rich History." *The Dish*, May 6, 2012. http://www.thedishmadison.com/2012/05/06/bellini.
CT. "La Follette Rejects Move to Cool Sale of Hot Dogs." October 3, 1978.
———. "Taco John's Denied Williamson Permit." October 26, 1976.

BIBLIOGRAPHY

Darlington, Tenaya. "Hello, Deli! Bialy Brown's Brings the Taste of New York to State Street." *Isthmus*, May 18, 2001.

Davidoff, Judith. "A Bitter Aftertaste: Kafe Kahoutek Customers Seek Compensation for Unused Gift Certificates." *Isthmus*, February 16, 1996.

———. "Mediterranean Madness: Two New Restaurants Bring Regional Favorites to Madison." *Isthmus*, December 13, 1996.

———."A Restaurateur's Return: Biagio Gargano Comes Out of Retirement to Open a New Pizzeria." *Isthmus*, June 26, 1998.

Elbow, Steven. "Ella's Deli Carousel Gets a Face Lift." *CT*, April 3, 2001.

Graham, Niki. "Ella's Deli." *Window*, October 10, 1978.

Gribble, Roger A. "All Aboard for New Restaurants: Cafe, Fine-Dining Bistro Will Set up in Depot." *WSJ*, September 4, 1994.

———. "Owners Will Sell Ella's on State." *WSJ*, August 4, 1999.

Hopfensperger, Jean. "The Theme Restaurant Explosion." *In Business*, October 1983.

Jaeger, Richard W. "Critics Panned Their Town, so They Gave It a Makeover." *WSJ*, February 2, 1998.

Kalk, Samara. "No Meals Skipped as Ella's Becomes Cafeli." *CT*, August 11, 1999.

———. "Warm, Cozy Lao Laan-Xang Fills Willy St. Void." *WSJ*, December 16, 1999.

——— (as Samara Kalk Derby). "Hawk's to Rejuvenate Ex-Ella's Spot on State." *WSJ*, August 22, 2002.

——— (as Samara Kalk Derby). "Lao Laan-Xang to Open 2nd, Larger Restaurant." *WSJ*, February 3, 2005.

——— (as Samara Kalk Derby). "Mercury Deli Gets New Owner, Will Become Cafe." *CT*, March 20, 2003.

Kallio, Sandra. "Chicken, the Old-Fashioned Way." *WSJ*, April 3, 1985.

Kallio, Sandra, and John Kovalic. "Dessert Hearts Can Warm Yours." *WSJ*, January 6, 1991.

Kasprzak, Wave. *It Takes More Than a Chef: Recipes & Stories from The Dining Room at 209 Main*. Monticello, WI: Good Food Good People, 2010.

Lusson, Joe. "Willy Street Works on Image." *WSJ*, May 17, 1989.

Marandino, Cristin. "Make Time for Savory Thymes." *Vegetarian Times*, October 1997.

Marsh, Pete. *The Story of Chili Al Felly*. https://www.youtube.com/watch?v=PdXEH4DZ6lM.

Martell, Chris. "Lao-Laan Xang Adds to Laotian Offerings." *WSJ*, March 24, 1991.

Minnich, Jerry. "Wild and Willy: Politically Correct Dining on Williamson Street." *Isthmus*, February 26, 1988.

Moe, Doug. "Gino's—50 Years of Serving Madison." *WSJ*, July 5, 2013.

BIBLIOGRAPHY

Mongold, Lorraine Howe. *The Angel of Williamson Street: The Autobiography of Lorraine Howe Mongold*. Madison, WI: Lorraine Howe Mongold, 1979.

Muckian, Michael. "Here Are Cornucopia Awards for Madison's Best Dining in 1994." *CT*, December 31, 1994.

———. "Shush! Keep This Gem a Secret." *CT*, October 12, 1996.

Murray, Catherine. "'Chili Al' Felly Kept East Siders Well Fed." *WSJ*, October 5, 2008.

Newman, Judy. "Home-Grown Restaurants Are Booming." October 30, 1994.

Peterson, Gary. "Lorraine Turns Tears into Smiles." *CT*, March 3, 1978.

Rath, Jay. "Ella's Deserves Landmark Status." *CT*, June 12, 1993.

———. "Savory Thymes, Vegetarian Eatery, Tasty and Tasteful." *CT*, July 4, 1992.

Scherer, M.A. "Bahn Thai Adds Spice to the Local Restaurant Scene with Hot Stuff!" *CT*, January 30, 1985.

Schubert, Sunny. "'Bahn Thai' a Delight Despite Service." *WSJ*, January 27, 1985.

———. "Who Is the Maitre D'—A Lion." *WSJ*, March 11, 1980.

Smith, Susan Lampert. "Newest Bahn Thai Restaurant Is Hot Item on Williamson St." *WSJ*, March 13, 1988.

Trott, Walt. "Ella's Deli: Great Food, Great Fun." *CT*, August 19, 1983.

Wineke, William R. "The Angel of Williamson Street." November 3, 1972.

WSJ. "Fire Damages Business." June 19, 1990.

INDEX

INDEX

INDEX

INDEX

INDEX

INDEX

INDEX

INDEX

ABOUT THE AUTHORS

Nichole Fromm was born in Milwaukee, Wisconsin, and grew up in Illinois and Texas. Originally from Osseo, Wisconsin, JonMichael "JM" Rasmus moved to Hudson when he was twelve. They met at the University of Wisconsin–Eau Claire, where JM got a bachelor's degree in mathematics with minors in chemistry and theater, and Nichole received one in German with minors in music and library studies. There they also fell in love.

Moving to Madison for jobs and more school in 1999, they married the following year. In 2004, they began "Eating in Madison A to Z," a weblog chronicling their alphabetical adventure in the capital city's food scene.

Since then, Nichole and JM have eaten at nearly one thousand Madison-area restaurants. The blog has been described as "honest" and "helpful" by people on the Internet.

Today, Nichole works as a librarian and enjoys bicycling. JM works at the Wisconsin Lottery and is a popular music scholar. He has co-designed two board games: Those Pesky Garden Gnomes (Rio Grande) and Double Feature (Renegade).

This is the first book for both authors. They live in Madison with their dog.

Visit us at
www.historypress.net
...

This title is also available as an e-book